# *Morse, Lewis, Endeavour* and Oxford

## A Guide Celebrating 35 Years on Screen

Edited by John Mair with
Richard Lance Keeble and Heidi Boon Rickard

Cover by

## Dean Stockton

Published by Bite-Sized Books Limited 2021

Bite-Sized Books Ltd, 8th Floor, 20 St Andrew St, London EC4A 3AY
**Registered in the UK.**
**Company Registration No: 9395379**

**ISBN: 9798751824754**

# Acknowledgements

There are many to thank for delivering this book in record time. It was only conceived in August 2021 and in the shops for October 2021. It has been made much easier by the sheer hard work of my two co-editors – Heidi Boon Rickard and Richard Lance Keeble. One provided the meat on the Oxford of Morse, the other his usual massive sub-editorial skills. I could not have done it without them.

Our publishers the old Bite-Sized (Paul Davies) and the new (Julian Costley) were also very supportive. We thank them and hope you enjoy the fruits of our labour.

John Mair, Jericho, Oxford

Heidi Boon Rickard, Chinnor, Oxfordshire

Richard Lance Keeble, Withcall, Lincolnshire

*'it's beginning to Thaw'*
*Endeavour, Terminus 26/9/21*

*Best wishes*
*Heidi*

# The Editors

This is **John Mair**'s 43rd book in the last decade. He invented with Richard Lance Keeble the 'hackademic' genre which mixes the work of journalists and academics. His edited books have ranged in subject from the future of the BBC (grim) to the Covid pandemic (grim) to the future of Guyana as a nascent oil state (bright). He is a former TV producer and has lived in or around Oxford for thirty years. He is an avid watcher of the *Morse* TV franchise.

**Richard Lance Keeble** is Professor of Journalism at the University of Lincoln and Honorary Professor at Liverpool Hope University. He has written and edited 44 books on a wide range of media-related topics. He is also emeritus editor of *Ethical Space: The International Journal of Communication Ethics* and joint editor of *George Orwell Studies*. In 2011, he gained a National Teaching Fellowship, the highest award for teachers in Higher Education in the UK, and in 2014 he was given a Lifetime Achievement Award by the Association for Journalism Education.

**Heidi Boon Rickard** is a qualified green badge guide, a member of the Institute of Tourist Guiding and the Oxford Guild of Tour Guides. After studying 'Travel and Tourism' at college, Heidi went on to live, work and travel in various countries. Settling in Oxfordshire with a young family, she re-trained as an Oxford guide in 2012. She founded Walking Tours of Oxford (www.walkingtoursofoxford.com) in 2013 and it has been the tour company of choice for thousands of visitors to the city. She has won numerous awards for tour guiding while WTO is the highest-rated tour company in Oxford.

# Contents

## Section 3: Morse the Copper

## Section 4: The Early v. the Late Morse

# Section 5: Oxford and Morse

# SECTION 1
## Stepping through 'Morseland'

# Introduction

John Mair

This is a comprehensive guide to the Oxford of *Morse*, *Lewis* and *Endeavour*. Nobody else has attempted it and we felt it should be done to mark thirty-five years since the first *Morse* on ITV in 1987. The 2021 series of three *Endeavour* episodes may well be the last iteration of the *Morse* franchise. Lips are sealed on that.

At the centrepiece of this guide is a walk by the doyenne of Oxford Walking Tours, Heidi Boon Rickard. In eight stops in central Oxford, she covers the filming of the three series very well. Use it as your bible. It is essential and full of surprises. Tucked on to that is a short guide to the Jericho – ten minutes' walk from the city centre – of *Morse* (and *Lewis*). It is after all the scene of the very first TV *Morse*, 'The Dead of Jericho' and a district interesting in its own right. I know – I live there.

But this is much, much more than a dry tourist guide. It is also an informative guide to Morse's creator Colin Dexter: his writings, his leisure activities, his pub-goings, and their place in the city. There is much exciting and stimulating reading in these ten extra chapters. They range from a revealing interview with Dexter to an analysis of the first Morse novel *Last Bus to Woodstock* to the reflections of his editor at Macmillan on their partnership to the inspiration he provided for the writer Cara Hunter and her 'New Morse', Inspector Adam Fawley.

We also examine the credentials of Morse, the policeman, with the former Chief Constable of his force and a retired 'Morse' – and an Oxford DI. We compare the 'late *Morse*' with the 'early *Endeavour*' through the eyes of two academics. We enter the *Morse* Universe through the eyes of one of the biggest fans of the franchise and look at whether Oxford is missing many tricks in not developing Morse tourism. Imagine Stratford without Shakespeare, Bath without Jane Austen – then that would be Oxford without Endeavour Morse.

And for the true believers we set out in two appendices the filmography of the *Morse* franchise and a fuller location guide to the settings for the three series.

By the end, you should be thoroughly immersed in all the facets of 'Morseland'. Enjoy the journey. Start it with Heidi Boon Rickard in St Giles in the city centre just outside those great Oxford landmarks, the Randolph Hotel and the Ashmolean Museum.

# Chapter 1

## A Guide to the Oxford of *Morse, Lewis* and *Endeavour* – In Eight Parts

*On set: Heidi Boon Rickard with Thursday and Endeavour*

Heidi Boon Rickard is THE *Morse* guide I n Oxford. Her Walking Tours of Oxford are regularly packed out. Here, in eight parts, she takes us on a tour of central Oxford's 'Morseland' sites and shows how they feature in the three series.

## Stop One: St Giles and the Martyrs' Memorial

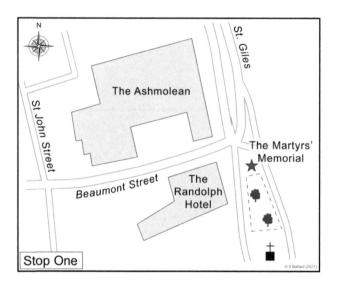

There are many Oxford Martyrs but when one refers to 'The' Oxford Martyrs it is in relation to three gentleman of the church – the Bishop of Worcester, Hugh Latimer, the Bishop of London, Nicholas Ridley, and the Archbishop of Canterbury, Thomas Cranmer. It was during the reign of Queen Mary, or 'Bloody Mary' (1553-1558), when she was seeking to return the country back to what she saw as 'the one true faith, Catholicism', that these three eminent clergymen were burnt alive at the stake: Latimer and Ridley, in 1555, and Cranmer, who initially recanted but was burnt six months later in March 1556. This did not happen at the place where the memorial stands but around the corner in the old city ditch that is now Broad Street. A cross in the road marks the spot and there is a plaque on the wall of Balliol College opposite the cross.

The memorial was erected some 300 years after those events, being completed in 1843 after two years of work and is designed by George Gilbert Scott. The three statues of Latimer, Ridley and Cranmer are by Henry Weekes. It is Victorian Gothic architecture and Grade 2 listed against development.

For anyone familiar with the world of *Morse, Lewis* and *Endeavour*, you will instantly recognise this memorial as it has been seen frequently in the three series.

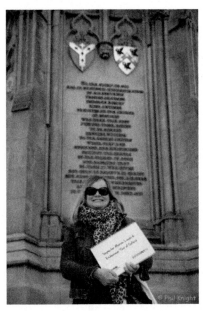

*Starting off: Heidi Boon Rickard in front of the Martyrs' Memorial*

## Morse: 'The Wolvercote Tongue' – Series 2, Episode 1

*'The one with the Americans on a coach trip'*

In this episode, we see the memorial as American tourists arrive in Oxford with the tour guide on her microphone along St Giles. The tour guide is Shella Williams (played by Roberta Taylor) and she is a little fed-up with the group. She also has a fondness for gin and tonics. I love the dialogue between Sheila Williams and the American tourist, Shirley Brown, when she is left somewhat aghast by people actually walking!

> Sheila Williams: 'This street's called St Giles and there's been a fair here every September since the Middle Ages. The whole road is blocked for days.'
>
> Shirley Brown: 'Well, how do people get around?'
>
> Sheila Williams: 'They walk.'

There is, indeed, a fair held every year on St Giles although it was cancelled in 2020 due to the pandemic – and revived again in the following year.

### Favourite Lines:
'I don't think, Lewis, I deduce. I only ever deduce.'

### Spot the Colin:
In this episode, we see a young Colin Dexter, author of the *Morse* novels, in the background in the Morse bar of the Randolph Hotel. Lewis buys Morse a pint and he comments on how well-kept the ale is.

### Connections:
Julian Mitchell wrote the story line of 'The Wolvercote Tongue' and Colin Dexter based his full-length novel, *The Jewel That Was Ours*, from this.

## *Lewis*: 'Reputation' – Series 1, Episode 1
*'The very first Lewis'*

Lewis has been working overseas after the loss of his wife, Valerie, in a hit-and-run accident and the death of Morse. His plane lands at Heathrow and he is greeted by Hathaway whom we are meeting for the first time. As they exit the airport, Lewis is almost hit by a car as he is crossing the road. Maybe jet lag has made him a little disoriented and he looks up to see a red Jaguar similar to the one that Morse drove. Hathaway then returns him to Oxford as we see them approaching along St Giles with the Martyrs' Memorial in view.

### Favourite lines:
Laura Hobson to Lewis:
'Can you turn down the volume on that shirt?'

### Spot the Colin:
In this episode, he is a porter at Wadham College who shows Lewis and Hathaway the way to Danny Griffin's room.

## Connections:

Danny Webb is playing Tom Pollock in this episode and we see him again as DS Lott in the pilot episode of *Endeavour* and in *Endeavour*, 'Harvest'.

## *Endeavour*: 'Fugue' – Series 1, Episode 1

*'The one with lots of dead bodies'*

This is a dark episode with many dead bodies piling up, but it is the episode when we begin to see the foundations of the relationship between Fred Thursday and Endeavour develop. It is also when we meet the rest of the Thursday family.

Around halfway through, a young girl (Debbie Snow) goes missing from an ice cream van and all that is left in the middle of the street is her red shoe.

Endeavour knows she is being held somewhere and that he has a certain amount of time to save her, but he just cannot get to the answer and understandably it is upsetting him. He pulls up at the Martyrs' Memorial in the dark, trying to process his thoughts, and looks up to see the memorial.

From this, he deduces that she is being held in a local church and is going to be cremated alive (burnt alive, just like the Martyrs) but he gets his answers and rushes to save her. But then it is revealed that she was never in real danger and was just used to test Endeavour.

It does have one of my favourite lines from Fred Thursday (there are many though).

### Favourite Lines:

Fred Thursday to Endeavour:

'One day I'll send you out for a routine inquiry and it'll turn out to be just that, but I won't hold my breath. You'd find something suspicious in a saint's sock drawer.'

### Spot the Colin:

See Trinity College stop.

**Connections:**

Laura Rees plays Faye Maddison, the sister of Philip, and she is also in the *Lewis* episode, 'The Great and The Good'. You will also notice the Randolph Hotel on the opposite side here, used often before inside and out in various episodes.

*Directions*

*From the memorial, cross over the road away from the Randolph, turn right and walk down Magdalen Street and turn left into Broad Street. Stop on your left outside the Blue Gates of Trinity College.*

## Stop Two: Broad Street and Trinity College

Trinity College was founded in 1555 by Thomas Pope who was in the service of Henry the Eighth. Like many Oxford colleges, Trinity is on the site of an old monastic foundation, Durham College. Trinity is a treat because rather than the imposing stone facades that do not allow a glimpse inside, you can, in fact, have a peek into the front gardens and appreciate some of the grounds (there are larger and extensive gardens at the back).

Straight ahead of you, through the Blue Gates, stands the chapel of Trinity which is where Thomas Pope was buried in 1559. Look up and appreciate the skyline of the chapel as this is relevant to some of our

plots. Trinity is usually open to the public. The college is worth a visit inside for the beautiful gardens and the chapel is exquisite with its five types of wood sculptures by Grinling Gibbons (1648-1742). If you can take a detour inside, then I would suggest doing so.

*Through the gate: Trinity College*

## *Morse:* Twilight of The Gods', Series 7, Episode 3

*'The one with the opera singer'*

A wonderful episode and with a strong cast. Gladys Probert is a Welsh opera singer; Morse takes a bit of a fancy to her as he is partial to a pretty lady who is an opera singer too! She is shot at Encaenia which is the ceremony where honorary degrees are conferred. The procession is filmed as it travels along Broad Street, just as Encaenia would take place in real life, usually on the Wednesday of ninth week of Trinity Term. Gladys is shot as she approaches the Sheldonian Theatre, further along but just off the Broad. When she is shot, all the dignitaries of the ceremony are detained inside the Sheldonian Theatre.

Sir John Gielgud, a fabulous British actor, plays Lord Hinksey and is not impressed to be detained. All he wants is his lunch. He finally gets to have his lunch along with the other dignitaries inside the dining hall of Trinity College (if your timing is right by avoiding mealtimes, then the dining hall is usually accessible to the public).

Morse:

Allowing the pages of *The Sun* to pass before your eyes does not amount to reading, Lewis.'

### Spot the Colin:

There are a priceless few seconds of Colin on screen, the facial expressions are fabulous. He is seated behind Lord Hinksey (John Gielgud) in the Sheldonian Theatre whilst he is requesting his lunch.

### Connections:

Robert Hardy is Andrew Bayden and he is also in the episode of *Lewis*, 'Dark Matter'.

## *Lewis:* 'The Gift of Promise' – Series 5, Episode 4

*'The one with the parkour'*

A young talented student: Zoe Suskin, only 15-years-old, appears to be a student at Trinity College and is a friend of Elmo, who is the parkour. You need to look straight-ahead through the gates and to the roofline of the chapel which is where Elmo jumps to his death.

### Favourite Lines:

When Hathaway goes to the book-signing and meets Grace Orde (played by Cherie Lunghi) and asks her to make it out to 'James':

Grace: 'I had a whippet called Jimmy, he was fit and lean and very, very fast.'

Hathaway: 'I am very much a James.'

### Spot the Colin:
No appearance.

Anne Chancellor, as Judith Suskin, is also in the *Morse* episode, 'Cherubim and Seraphim'.

## *Endeavour:* 'Fugue' – Series 1, Episode 2

*'The one already mentioned at the Martyrs' Memorial'*

It is quite a dark episode with many grisly murders. They bring in a psychologist to help with the case. A serial killer, Dr Daniel Cronyn, who is operating under the pseudonym, Keith Miller, lures Fred Thursday to the roofline at Trinity College whilst a piano recital is taking place in the chapel underneath. Endeavour works out what is going on (the anagram, I AM KILLER, provides a crucial clue at one point) and climbs up to the roof to save Thursday. To me, this is an iconic scene in which the bond is developing between Fred and Endeavour – with Oxford in all her beauty as the backdrop. The last scene gives me goose bumps as it plays out and Oxford is tinged with a red skyline.

### Favourite Lines:

Thursday: 'A case like this will tear the heart right out of a man, find something worth defending.'

Morse: 'I thought I had … found something.'

Thursday: 'Music? I suppose music is as good as anything … go home, put your best record on, loud as it will play and with every note you remember that's something that the darkness couldn't take from you.'

### Spot the Colin:

We catch a very brief (and slightly faded) view of him when Philip Maddison is playing in the chapel of Trinity College. As the piano recital is taking place, the music reaches a crescendo and the action is playing out on the roof.

### Connections:

It's the fear of heights for young Endeavour. Is this the start? We see it clearly in the *Morse* episode, 'Service of All the Dead'.

This is one of my favourite spots as there is so much to talk about here. With the Blue Gates of Trinity behind you, swing round so that they are now behind you and look to the opposite side of the road. Café ItaliaAmo (today it has a brilliant secret garden: do explore it) was formerly called 'Morton's' and it appears in the *Lewis* episode, 'Reputation'. We see Lewis and Hathaway go there to buy their lunch; they cross over and stand talking at the Blue Gates of Trinity. Blackwell's art and poster store is where, in the *Lewis* episode, 'Music to Die for', Valli Helm works. She places the advertisement in the paper at the start of the episode which reads 'E. Morse, forever remembered, Love W.'. In many of the *Lewis* episodes, we have a reference taking us back to *Morse*.

Cheryl Campbell, who plays the character of Valli, was also in the *Morse* episode, 'The Infernal Serpent'. Look up above Blackwell's art and poster store and you will see the Anthony Gormley statue and the corner here forms the roofline for Joan Thursday's flat.

### Directions

*Next, you continue along Broad Street passing 'The White Horse' pub on your left. (Note the back and white chalkboard advertising Morse links.) Continue until you reach the Weston Library on your left and stop by the steps.*

## Stop Three: Weston Library

On the opposite side of Broad Street, we see the Sheldonian Theatre and Museum to the History of Science. A brief history of these buildings – the Sheldonian Theatre is the ceremonial hall of the university and was designed by Sir Christopher Wren who studied at Oxford; he was at Wadham (just around the corner) and then at All Souls College, located in Radcliffe Square.

The Museum to the History of Science can claim to be 'the world's oldest purpose-built museum' for this was the old Ashmolean but as the collection grew, they needed more space and so the Ashmolean Museum, on Beaumont Street, was built (just close to the start of the tour).

The Weston Library is part of the Bodleian library, one of the oldest libraries in Europe. Construction began in the 1940s and 60 per cent is underground. There are tunnels which connect this, the 'new Bodleian', as it is known, to distinguish it from the old Bodleian which we shall see shortly. We have seen chase scenes, secret meetings and dead bodies in these tunnels in the *Morse* universe!

## *Morse*: 'The Dead of Jericho', Season 1, Episode 1
*'The first Morse'*

*In the first* Morse: *'The White Horse' pub*

'The White Horse' pub, which we passed on the left-hand side, was used in the filming of the first-ever TV episode of *Morse*, 'The Dead of Jericho'. It was here that Morse and Anne Staveley, played by the Gemma Jones, have a drink. They then come out of the pub, cross over Broad Street, weave through the Bodleian Library to find themselves in Jericho. In reality, Jericho is some distance from here in the opposite direction! Of course, the TV episodes were filmed out of sync as the first Dexter book was *Last Bus to Woodstock*.

### Favourite Lines:

Anne and Morse are walking to Jericho:

Anne: 'I don't know your first name.'

Morse: 'That's right.'

Anne: 'So.'

Morse: 'I don't use it.'

Anne: 'Don't be silly.'

Morse: 'It was my parents who were silly.'

Anne: 'What do your friends call you?'

Morse: 'Morse.'

This is such a relevant conversation since the first name of Morse does not become known until 'Death is Now My Neighbour'. Morse will often say that his first name is 'Inspector'.

### Spot the Colin:

He can be seen in the cloisters of Magdalen College and as Morse walks past he glances back at Colin.

### Connections:

In the opening scene, we see the famous red Jaguar being driven by Morse – registration 248 RPA. We see this car also in the pilot episode of *Endeavour* when it is in the car showroom.

## *Lewis:* 'One for Sorrow', Season 9, Episode 1

*'The one with taxidermy'*

As we get to the end of the *Lewis* series, they started to show the episodes across two parts. I always found this odd and did not like the format. This is one such episode – the one with taxidermy and all the stuffed animals. In the second section, we see Lizzie Maddox walk up the steps of the Weston Library and across the atrium. The camera next cuts to Lewis and Hathaway in the library locating a book to help with the case.

### Favourite Lines:

Lewis: 'If we arrested every oddball there would be a teaching crisis at Oxford.'

## Spot the Colin:

No appearance.

## Connections:

We meet Hathaway's father who has dementia. We also see a young Philip Hathaway in the *Endeavour* episode, 'Prey'. Fred Thursday and Endeavour visit Philip who is a groundsman at Crevecoeur Hall. So, a young Endeavour has meet Hathaway's father! We also see a return to Crevecoeur in the *Lewis* episode, 'Dead of Winter'.

## *Endeavour:* 'Trove', Episode 1, Series 3

*'The one with the beauty pageant'*

On Broad Street we see the beauty pageant taking place and the protestor gets up on to a float and shoots a gun. There is red everywhere, but it is revealed that the gun contains red paint rather than bullets.

## Favourite Lines:

Max: 'Multiple catastrophic injuries, to you, to be getting on with. Chapter and verse once I've had a rummage.'

## Spot the Colin:

Looking relaxed and sitting on a bench in Merton College as Endeavour and Thursday walk around – 30 minutes in.

## Connections:

David Westhead as Val Todd is also in the *Lewis* episode, 'The Gift of Promise'.

## Directions

*Cross over the road to the Clarendon Building on the opposite side and then turn right into Catte Street. Stop at the Bridge of Sighs on the left.*

# Stop Four: From the Bridge of Sighs

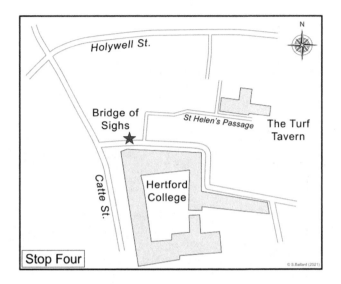

The Bridge of Sighs was designed by Thomas Graham Jackson to connect the two sides of Hertford College. You can see the date by looking up to see the year marked – 1913, which is new by Oxford standards. This area – the bridge and New College Lane – is used many times in the TV series. As also is New College, the entrance to which is located further along New College Lane. This dates from 1379.

## *Morse*: 'Service of All the Dead', Series 1, Episode 3

*'The one where Morse is scared of heights'*

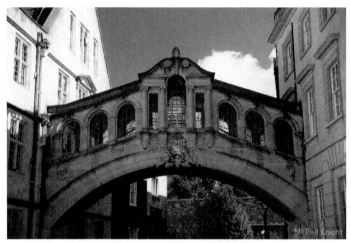

*Shades of glory: The Bridge of Sighs*

As you look under the Bridge of Sighs, to the left between the stone and brick walls, you should notice a small alleyway which is 'St Helen's Passage'. If you walk down here (one for later) you come to 'The Turf Tavern' which is one of the oldest pubs in Oxford and located in the old city ditch. In the *Morse* episode 'Service of all the Dead', Morse, ever partial to a pretty lady, takes a fancy to Ruth Rawlinson who is a suspect in the case. Morse asks her out for a drink, but she declines. That same evening, Lewis and Morse walk into 'The Turf Tavern' and Lewis asks his boss what he would like to drink. Morse sees Ruth Rawlinson having a drink with a man, becomes a little agitated and so refuses the drink from Lewis – virtually unheard of!

### Favourite Lines:

Morse to Lewis:

'I'm scared of heights, you stupid sod' (this ties in with the *Endeavour* episode, 'Fugue')

## Spot the Colin:

We see a young Colin talking to a lady in blue as Morse walks past. This is Merton College.

## Connections:

Merton College is used in this episode and frequently in all three series – such as in *Morse*: 'The Infernal Serpent', *Lewis*: 'Your Sudden Death Question' and *Endeavour*: Pilot.

## *Lewis*: 'And the Moonbeams Kiss the Sea', Season 2, Episode 1

*'The one with the dodgy tour guide'*

I love this episode as it features a very 'dodgy' tour guide, Nell Buckley. She brings her group through 'The Turf Tavern' (from the other side) and when they exit here, via St Helen's Passage, and see the Bridge of Sighs, she informs her group that this is where the Cambridge Spies (Anthony Blunt, Guy Burgess, John Cairncross, Donald Maclean and 'Kim' Philby) would meet!

## Favourite Lines:

Nell Buckley, tour guide to her group:

'It was here last November, that a fully-grown crocodile was spotted, photographs appeared in the press, there were items on the national news and although the crocodile was never caught there were unconfirmed reports that two dogs disappeared without a trace at the time as well as a prize-winning Siamese cat belonging to a Professor of Biochemistry. Philip has some photographs of this crocodile which makes attractive and rather unusual postcards available at a nominal charge ... Thank you for being such a lovely audience: you are a credit to Charles Darwin.'

## Spot the Colin:

Lewis interviews a builder in the front quad of Corpus Christi College and Colin can be seen in the background.

Caroline O'Neil plays Susan Chapman and she is, of course, Winn Thursday in *Endeavour*.

## Endeavour 'Deguello', Series 6, Episode 4

*'The one with the tower block and the shoot-out'*

Reading comments and reviews, feelings are mixed about this episode, but I enjoyed it – especially with the final scene when 'Oxford's finest' pull together. It is all looking rather glum as Max has been taken hostage and Endeavour, Thursday, Police Superintendent Reggie Bright and Police Constable Jim Strange are in a stand-off with Jago.

Before this final shoot-out, we see a school trip standing under the Bridge of Sighs with the teacher explaining it to them when Bright walks past. One of the children notices and says: 'Look: Pelican man!' Bright continues along New College Lane to find himself in mortal danger, trapped by two thugs with knives. The school children run after him, crowd around and ask for his autograph – thus saving him.

This is also the episode when we have the badly-built tower block which comes tumbling down due to the use of cheap sand. The tower block is called 'Cranmer House' and stands on 'Martyrs' Grove' – so yet another connection to the previously-mentioned Oxford Martyrs.

### Favourite Lines:

#### Max:

'Will be able to give you chapter and verse after the post-mortem. Shall we say 2 o'clock?'

#### Spot the Colin:

It is hard to spot him, but Endeavour is at the scene of a drug overdose and in the graffiti on the wall it says: 'Dexter was here.'

#### Connections:

At the end, Endeavour has bought his 'forever home'; we see him put the key in the lock and enter the home he has in *Morse*.

Before moving on from this spot, swing around to admire the view, looking back at the Sheldonian Theatre and the other side of the

Clarendon Building. It was here, as the processions exits through the Clarendon Building, where Gladys is shot in 'Twilight of the Gods'. All the dignitaries are then detained in the Sheldonian Theatre.

This location is also recognisable from the *Endeavour* episode, 'Harvest', in which a CND protestor 'Nigel Warren' preaches at the start of the episode. We see him again later when Thursday and Endeavour come to talk to him about hitching a lift five years ago with a Dr Matthew Laxman. It is in this *Endeavour* episode when Shelia Hancock, John Thaw's widow, has a role.

### Directions

*Continue walking along Catte Street and turn right into Old School's Quadrangle. Position yourself by the statue straight ahead.*

# Stop Five: Across Broad Street to the Divinity School

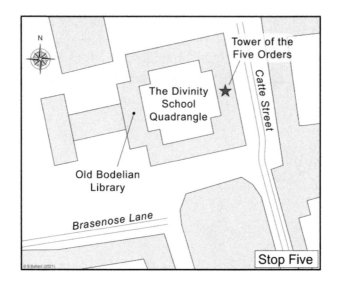

The statue here is of William Herbert, 3rd Earl of Pembroke (1580-1630), Chancellor of the University when this area was built in the 17th century. You will see above the archway, the Tower of Five Orders, the columns on either side representing the five orders of architecture: Tuscan, Doric, Ionic, Corinthian and Composite. Straight ahead of you (opposite the tower and behind the statue) is the entrance to the exquisite Divinity School. This is worth a visit: you may recognise it from the *Harry Potter* movies. Above the Divinity School is the Duke Humphrey's Library, the oldest reading room of the Bodleian Library, named after Humphrey of Lancaster (1390-1447), younger son of King Henry IV.

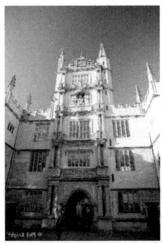

*Towering over students: Tower of Five Orders*

All year round, this area can be very busy with students back and forth looking for books for their studies. Often large tour groups will also congregate in this area with their guide to be told about the history of this most magnificent library. Consequently, it is not an easy location for filming. All the same, Morse strides across this area in various episodes and the library's interior has also been used in a number of episodes.

## *Morse*: 'The Settling of the Sun', Series 2, Episode 3

*'The one with the Japanese'*

A bus arrives at Radcliffe Square with summer students, and they check in to Brasenose College. Morse is dining at High Table and a Japanese student leaves, feeling unwell. He is later found murdered. Morse, coming away from an exhibition in the Divinity School, stands by the Earl of Pembroke statue for a few moments. He is carrying a programme (containing reproductions of the 'Lamentation of Christ' by both Giotto and Salvador Dali that show the stigmata) and exits under the Tower of the Five Orders.

### Favourite Lines:

'The most suspicious thing is an excellent alibi.'

Morse takes Alex Robson to hospital to visit her aunt and Colin is a doctor standing on the left.

## Connections:

Gordon Kennedy is the link here, appearing in this episode and then in *Endeavour*'s 'Neverland' as Alderman Gerald Wintergreen.

## *Lewis*: 'Whom the Gods Would Destroy', Season 1. Episode 1

Four men formed a club in their student days at Oxford: the Sons of the Twice Born. One of them is in a wheelchair and after two are murdered, it becomes apparent that they hold a secret from their past. Lewis and Hathaway seek out Professor Gold at the Bodleian Library.

## Favourite Lines:

When Lewis and Hathaway find Professor Gold in the Duke Humphrey's Library, they ask her to translate something. I particularly like the 'perhaps in another life' conversation between Lewis and Professor Gold which is echoed in the pilot episode when Endeavour meets journalist Dorothea Frazil for the first time (played by Abigail Thaw, John Thaw's daughter).

However, it is the exchange between Hathaway and Professor Gold that wins overall for me!

Hathaway: 'They are all Greek to me'

Professor Gold: 'You are a scholar?'

Hathaway: 'Yes.'

Professor Gold: 'Cambridge?'

Hathaway: 'What makes you ask that?'

Professor Gold: 'It would explain your limitations.'

## Spot the Colin:

He is dining at High Table at the beginning of this episode.

Anne Massey plays Professor Gold and she was also in the *Morse* episode, 'Happy Families'. In that episode, she is killed by her long-lost daughter and then reappears fit and well in this *Lewis* – hence the 'another life' line.

## *Endeavour:* 'Harvest', Series 4, Episode 4

*'The one with Sheila Hancock'*

We had a lead-up to this episode with the tarot card reader appearing at the end of the previous season's final episode. Sheila Hancock's character plays a lady living in the woods who shoots her grandson to avoid him going to prison. Thursday and Endeavour talk to Nigel Warren, who is preaching near the Bridge of Sighs. After the conversation we see Thursday and Endeavour walk through the quadrangle here – straight across from side to side. The camera pans out and we are given a beautiful aerial view of the whole quad and the Earl of Pembroke statue.

### Favourite Lines:

From Thursday:

'County couldn't find their arse with both hands and a map.'

### Spot the Colin:

This time we have Colin's bust in the professor's office.

### Connections:

There can be no stronger connection here with Sheila Hancock being cast.

*Directions*

**With the statue of the Earl of Pembroke in front of you, take the left hand 'tunnel' to exit the Old Schools quad and as you leave this area, you will be blown away by the view of the Radcliffe Camera.**

# Stop Six: Radcliffe Square

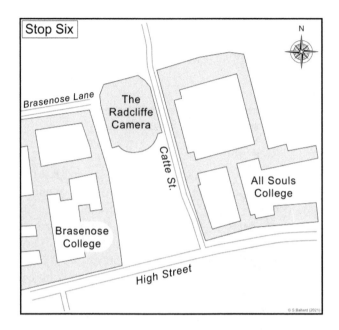

One of the most iconic parts of Oxford, Radcliffe Square is dominated by the Radcliffe Camera. It is used frequently in the filming of the three series. Look around, there is very little to date this area so it can easily be turned back to the 1960s/1970s for *Endeavour*.

'The Camera', which translates from Latin for room, is part of the Bodleian Library. John Radcliffe (1650-1714), royal physician to William and Mary, bequeathed upon his death money to build the camera (and the Radcliffe Infirmary, which is where *Morse* dies in 'The Remorseful Day').

With the Camera directly on front of you, let's talk about scenes filmed on both sides.

## Morse: 'Death is Now My Neighbour', Season 8, Episode 3

*'The one where we meet Adele Cecil'*

I often joke on my tours about how the actors will go in one door and then exit at a completely different location. This is one such episode. At the beginning we see a young lady applying her make-up for the day at her home. The next minute she is shot through the window. It ends

up being a case of mistaken identity. We then see the character Dennis Cornford, an academic of Lonsdale College who is in the running to take over as master of the college. We see him arrive at Brasenose College (to the right of the camera) in a car which parks outside; he then enters the college, and in the next scene we see him walking across the grass of Oriel College!

Towards the end, after Denis Cornfield's American wife has fallen down the stairs and he has been interviewed, we see Morse and Lewis exit on to Radcliffe Square (even though the previous scene was in Oriel again) and stand on Radcliffe Square with the church in the background. Laura Hobson arrives and asks Morse out for a drink, but he declines! A fabulous performance by Richard Briers as Sir Clixby Bream.

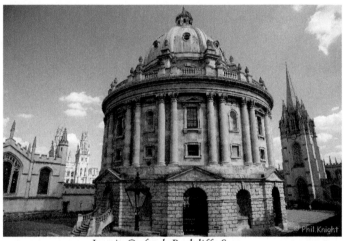
*Iconic Oxford: Radcliffe Square*

### Favourite Lines:

Morse gives Adele Cecil the cryptic clue for his name: 'My whole life's effort has revolved around Eve.' Later in the programme, in the pub, conversation is as follows:

Adele Cecil: 'This anagram: "Around Eve"? I've tried and I've tried, but all I can come up with is "Endeavour". And no-one's called Endeavour. Surely?'

Morse: 'I told you, my mother was a Quaker. And Quakers sometimes call their children names like Hope and Patience. My father was

obsessed with Captain Cook, and his ship was called *Endeavour*. Why aren't you both laughing?'

Lewis: [*mutters*]: 'You poor sod.'

Adele Cecil: 'I'm not calling you "Endeavour".'

Lewis: 'Call him "Sir". He likes that.'

Adele Cecil: 'Oh no. No, I'll stick to "Morse" – like everyone else.'

### Spot the Colin:

This is Colin's only speaking part where he says the Latin grace for the college before dinner and filmed in Oriel College.

### Connections:

Denis Cornford is played by Roger Allam who is later Fred Thursday in *Endeavour*.

## *Lewis*: 'Entry Woods', Series 8, Episode 1

*'The one where we meet Lizzie and Lewis returns'*

At the start we see (a drunk) Lizzie Maddox for the first time on the far side of Radcliffe Square. The next day she walks down Catte Street towards the Radcliffe Camera (on the left), on her way to interview an animal rights activist 'Jessica'. She phones Hathaway who insists on coming along and joining in the interview. As Hathaway arrives, we see the protestors in cages along the railing around the Camera dressed up as animals. Meanwhile, Lewis is putting together a canoe for (one assumes) his grandson.

### Favourite Lines:

Chief Superintendent Jean Innocent, the boss of Lewis and James Hathaway, as she tries to coax Lewis out of retirement:

'What are you doing after this?'

'Buying some waterproof glue.'

'Exciting. Alternatively, you can find out why a neurosurgeon has a bullet in his head.'

**Spot the Colin:**

We get a very fleeting glimpse of him sitting at a table when Lewis and Hathaway interview Lorraine Fernsby.

**Connections:**

The return of Lewis! It seemed to be all over at the end of episode 30 – but thankfully, Kevin Whateley was persuaded to return. However, it is general knowledge that Kevin has stated he will do no more *Lewis* episodes after the 33$^{rd}$ – to match the *Morse* series' total.

## *Endeavour:* 'Canticle', Season 4, Episode 2

*'The one with the pop video'*

The opening scenes are at New College where the video 'Kiss me', by Mimi, is being shot. The next scenes are filmed here on Radcliffe Square where we see an old 1960s bus parked on the right-hand side (as you look at the Camera).

Inside is the character, Joy Pettybon, who is reciting the Lord's Prayer. She gets off the bus and the vicar introduces her: 'Please welcome Mrs Joy Pettybon.' She addresses the crowd on Radcliffe Square: 'Last Wednesday we saw a programme and it was the dirtiest programme I have ever seen.' Her daughter, Bettina, takes a bit of a fancy to Endeavour.

**Favourite Lines:**

Fred Thursday, when talking about pot, tells Endeavour: 'You put enough beer away.'

Endeavour replies: 'Beer's brain food.'

**Spot the Colin:**

This is the first time we do not see him in real life as he was suffering from ill health at the time of the filming. Instead, we see his picture on the front page of the *Oxford Mail* that Endeavour is reading in his flat. He puts the paper down and the camera lingers for a few moments on the image.

**Connections:**

Russell Lewis wrote the *Morse* episode, 'The Way Through the Woods', and was involved with five *Lewis* episodes – 'Fearful Symmetry', 'Old, Unhappy, Far Off Things', 'Falling Darkness' and 'The Dead of Winter' – and has written all the episodes of *Endeavour*.

*Directions*

*From here, take the left hand side of the square and wander around looking at these beautiful buildings. When you reach the far side, we will be turning left and stopping just by Brasenose Lane.*

## Stop Seven: 'The Heart of Oxford'

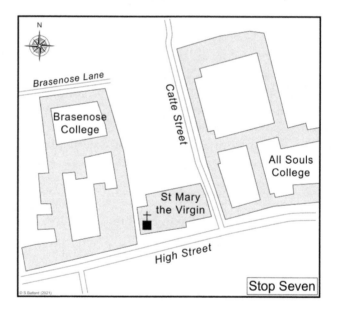

We have passed what many consider to be 'the heart of Oxford' as you walked round Radcliffe Square and the Camera. On your left you passed All Souls College which is for research fellows only. It was here where Sir Jeremy Morse (1928-2016) was an honorary fellow and the namesake of our Morse.

Colin loved crossword puzzles and this is a characteristic that he bestowed upon his character. Colin was also a great admirer of Sir Jeremy and that is how our Morse acquired his name.

*Special view: Peering out from Brasenose College*

At the end of the square, you will see the University Church of St Mary the Virgin, which was adopted as the university's first building – with its congregation meeting here since at least 1252. We would suggest a visit inside.

We next pass the entrance to Brasenose College, founded in 1509, notable alumni including the author of *The Lord of Flies* and winner of the Nobel Prize in Literature in 1983, William Golding, the *Monty Python* actor-cum-travel writer, Michael Palin, and the former British Prime Minister, David Cameron.

It commands a stunning location right in the heart of Oxford and from the front quad there are great views of the top of the Radcliffe Camera. The name of the college comes from its Brazen Nose door knocker: the original hangs behind High Table in the hall but a replica can be seen at the top of the door where the stone meets the wood.

Just beyond Brasenose is a left-hand turning called Brasenose Lane. Turn in here and position yourself at the corner so you can see the square, Camera and lane.

Brasenose Lane is perfect for filming as it is easy to block off. It has been used many times in the series. But when researching for this book, I found that I was struggling to find a *Morse* episode filmed here and my recollections were more of *Lewis* and *Endeavour* episodes. I wonder now if that is because, back in the day, when *Morse* was being filmed, Oxford was less busy. Nowadays (and certainly before Covid-19), Oxford is incredibly busy and that must have provided challenges for *Lewis* and *Endeavour* filming – so they chose roads and lanes that were slightly off-centre and quieter in comparison to the main touristy areas.

## *Morse*: 'The Way Through the Woods', Series 8, Episode 1

*'The one where we meet Laura'*

In the opening scene, we see a dog walker in the woods and soon afterwards the dog locates a skull. Stephen Parnell is attacked in the prison (which was filmed at Oxford Prison, now a luxury Hotel Malmaison) and retracts a confession as he lies dying. Morse can be seen driving the Jag through Radcliffe Square and then up Brasenose Lane. This is also the episode in which DCI Martin Johnson keeps calling Lewis 'Bob' until he corrects him by saying: 'I prefer Robbie to be honest or Sergeant Lewis.'

### Favourite Lines:

Laura Hobson arriving at Blenheim says:

'Do you know where I can find a Chief Inspector ... looks like Mouse? Morse's face is priceless as he replies: 'Morse, Detective Chief Inspector Morse.'

### Spot the Colin:

Right at the beginning, there is a drinks reception in Exeter College and he is enjoying a drink overlooking Radcliffe Square.

### Connections:

Morse goes into the bookstore, on Turl Street, and requests a text on the pre-Raphaelite painters (who had many Oxford connections and who are often mentioned in plots) from Claire Osbourne whom he had met at a concert and flirted with the night before.

## *Lewis*: 'Old School Ties', Series 1, Episode 2

*'The one with the annoying Geordie'*

Nicky Turnbull, a criminal turned author, has been receiving death threats and Lewis is asked to 'keep an eye on him'. Lewis really does not like him at all … 'He's everything I hate, celebrity criminal and professional Geordie.' It is at the University Church of St Mary the Virgin where we hear Laurence Fox as Hathaway play the guitar.

### Favourite Lines:

Chief Superintendent Jean Innocent to Lewis about Nicky Turnbull:

'He is from your part of the world so you can talk to him about whippets and leeks and Shearer [the Newcastle United and England football star]… is that his name?'

### Spot the Colin:

Following the press conference, Lewis speaks to Norman, the reporter. He returns to talk to Diane Turnbull (played by Gina McKee) and Jean Innocent and we see Colin in the background as an academic.

### Connections:

Charlie Reid, the bouncer, says: 'I was sorry to hear about Morse. He was a bastard but a straight bastard.'

*Directions*

*Continue up Brasenose Lane. You will be passing the side of Brasenose College on your left which turns into the side of Lincoln College. Behind the wall on your right is the Fellows' Garden of Exeter College. When you reach the top, turn left and position yourself on the corner of Brasenose Lane and Turl Street.*

# Stop Eight: Turl Street

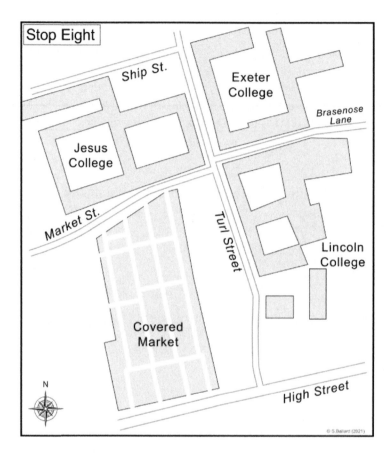

Turl Street has been used many times in the filming of the series. From your location, you can see three colleges – Lincoln College is behind you (where the post box is), on the opposite side and to your left is Jesus College.

Opposite Jesus College, off Turl Street, is the entrance to Exeter College which is the important one here although all are equally beautiful!

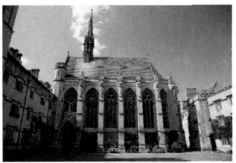

*Tour's end: Exeter College*

Exeter College was founded in 1314 by the Bishop of Exeter. Notable alumni include J. R. R. Tolkien, author of *Lord of the Rings*, who was a student here (although he also taught at Pembroke and Merton colleges). Exeter is often open to the public, in the afternoons between 2-5pm. There is a small charge to enter but is worth it to enjoy an overview of an Oxford college. Especially for anyone keen on *Morse*, *Lewis* and *Endeavour* for it is one of the most-used college locations for filming. In March 2020, I saw Shaun Evans here filming 'Striker' for Season 8.

## *Morse*: 'The Last Enemy', Season 3, Episode 2

*'The one with Morse's toothache'*

From your vantage point – look left towards the end of Turl Street and you will see a shop called 'Walters' on the right.

It is an idyllic day in Oxford as we watch the opening credits on the Oxford canal. A canal boat drifts towards the bank and a young lady uses the pole to push away – she finds a body in the canal, but this is different to the hundreds of other bodies (according to *Morse*, *Lewis* and *Endeavour*) found as this is only the torso – no head, arms or legs. But very handily he is still wearing his tailor-made suit. It falls to Lewis to find out for whom the suit was made, so he takes it into Walters, the men's clothing shop, at No.10 Turl Street. He comes out and bumps into Dr Grayling Russell, the pathologist employed before Dr Laura Hobson – but after Dr Max DeBryn and yet another lady whom Morse takes a fancy too! They go off down Turl Street talking about Morse's toothache!

### Favourite Lines:

At the end, Morse has taken Dr Grayling out for a drink and they are in the pub garden when an old friend of hers appears – Sam. Morse asks what he would like to drink and the reply is 'half a lager'. Morse's face is priceless … you can almost see the horror at anybody drinking half a lager!

### Spot the Colin:

He is possibly the passer-by at the very beginning of the episode on the Oxford canal although he is not listed in the credits.

### Connections:

Barry Foster is Alexander Reece and we see the character in the pilot episode of *Endeavour*. It is Alexander Reece who stole Morse's girlfriend – Susan/Wendy and why he failed to get his degree.

## *Lewis*: 'The Dead of Winter', Series 4, Episode 1

*'The one in which Hathaway returns home'*

The episode begins with an English Civil War battle re-enactment and a dead body is found on a tour bus. The investigation leads Hathaway and Lewis to Crevecoeur Hall, the ancestral home of the wealthy Mortmaignes where Hathaway grew up. Hathaway connects with friends from his past including the butler, Hopkiss, and Scarlett, the daughter of the Earl. One is left to surmise that there is a history between Hathaway and Scarlett and she asks him to call her. Hathaway replies that he does not have her number and she replies: 'You are a detective aren't you?' Hathaway visits the Oxfam bookstore on the opposite side of Turl Street and meets Scarlett again. She leaves by mistake her bank card and Hathaway runs after her into Turl Street.

### Favourite Lines:

Dr Laura Hobson to Lewis about Hathaway's court appearance:

'Knickers off clothes lines again. Let's hope the judge shows leniency.'

I could not locate him in this episode.

This all stems back to Hathaway's childhood which we have previously mentioned at Stop 3.

## *Endeavour:* 'Coda', Season 3, Episode 4

*'The one with the bank raid'*

Joan Thursday works in the bank and there is a raid. A police officer is shot and Endeavour, along with Joan, is caught up in the drama. This is also the episode when Fred Thursday has a piece of shrapnel near his heart which he conveniently coughs up! Near the beginning, Endeavour attends a music recital which is filmed in the Fellows' Garden at Exeter. He meets his old teacher, Dr Lorimer (played by Mark Heap) and when Endeavour later visits Lorimer, he asks Endeavour to investigate the activities of his wife.

What I find so poignant about this scene is the exchange between Endeavour and Lorimer at the end which is filmed in the front quad. Lorimer is encouraging Morse to think about his life: 'Love Morse, imagine that.'

We know Endeavour Morse never finds true love (unless you consider Adele Cecil, who appeared in just two episodes, 'Death is Now my Neighbour' and 'The Wench is Dead') and he collapses on the exact same spot where these words are spoken.

That scene could have been filmed in any college quadrangle, around any patch of grass. But the location team, the producers and the writer Russell Lewis choose this spot to film and capture those words. To me this is one of the most poignant scenes of *Endeavour*.

### Favourite Lines:

Fred Thursday:

'You know what they say about funerals ... someone always catches their death.'

Possibly cello player at concert (unconfirmed).

### Connections:

Lorimer recalls Morse being in love at college and recites the line: 'I saw an angel crossing Carfax'. Carfax is a prominent tower in central Oxford, at the junction of St Aldates, Cornmarket Street, Queen Street and High Street. Lorimer is referring to Morse's love for Susan/Wendy as mentioned in the pilot episode of *Endeavour* but also in the Morse episode 'Dead on Time'.

## By Way of an End to the Tour and for Morse

So, we come to the end of our short tour of Oxford. Our tours explore a lot further – both distance and scene-wise – but each tour we conduct is unique. This might depend on the guide, events in Oxford, closures, or even the weather: we will adapt each tour accordingly as we do not follow a script.

Oxford University, with its wonderful history dating back over a thousand years, is made up of 39 colleges and we have passed but a handful during this tour. At the time of the filming of the *Morse* episodes, many colleges were open to the public but nowadays fewer are. For further understanding of Oxford, we suggest a 'Simply Oxford' University tour with www.walkingtoursofoxford.com.

No *Morse*, *Lewis* and *Endeavour* tour would be complete without a mention of the last *Inspector Morse*, aired on 15 November 2000. John Thaw himself died on 21 February 2002. Colin Dexter had written in his will that nobody else should ever play Morse but we have been lucky with the portrayal of the young Endeavour by Shaun Evans who, given the shoes he had to fill, in my opinion has done a magnificent job. We are also grateful to Russell Lewis who has penned all episodes of *Endeavour*.

*Morse* ended at episode 33 as did *Lewis*; with three episodes due of *Endeavour* that will bring us neatly to 33. Will this be the end of *Endeavour*?

Do go into Exeter College if you are able to (subject to opening hours) and as you walk around the front quad and perhaps take a seat in the chapel, take a moment to think of our Morse, John Thaw and Colin Dexter with 'The Remorseful Day' in your mind.

## Morse: 'The Remorseful Day', Specials, Episode 33

*'The one where we say goodbye'*

In the very last *Inspector Morse*. John Thaw goes into Exeter College via the front door. He takes a telephone call from the porter's lodge and then goes into the chapel via front quad. He sits and listens to Gabriel Fauré's ethereal *Requiem* for a few minutes before returning to the front quad. It is here where he has his fatal heart attack. He is taken to the John Radcliffe Hospital where he dies. I have only watched this episode twice – once on the original screening in 2000 and again when I started to train as a *Morse* guide. Many guests on my tour have told me that they have never seen it as they cannot bear to watch it.

### Favourite Lines:

Lewis kisses Morse on the forehead and says: 'Goodbye sir.'

### Where's Colin?

I will leave this one for you to determine!

### Connections:

The title is from the poem by A. E. Housman (who, like Morse, was on a scholarship at St John's and failed his final exam) 'How clear, how lovely, how bright' which is recited by Endeavour in the episode 'Neverland'.

> How clear, how lovely bright,
> How beautiful to sight
> Those beams of morning play;
> How heaven laughs out with glee
> Where, like a bird set free,
> Up from the Eastern Sea
> Soars the delightful day.
>
> Today I shall be strong,

No more shall yield to wrong,
Shall squander life no more;
Days lost, I know not how,
I shall retrieve them now;
Now I shall keep the vow
I never kept before.

Ensanguining the skies
How heavily it dies
Into the west away;
Past touch and sight and sound
No further to be found
How hopeless underground
Falls the remorseful day.

# Chapter 2

## Explore Morse's Jericho and Discover its Secrets

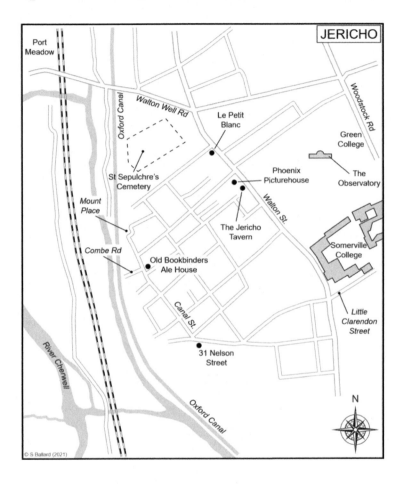

**John Mair takes us on a whistle-stop walking tour of the Jericho district of Oxford – fascinating in its own right and the scene of many Morse mysteries.**

Jericho is a writer's and film-maker's dream: with its rich history – once a red-light district – colourful terraces of houses, plenty of pubs and currently a hipster's paradise in the making if you believe the estate agents' hype. No wonder the likes of Philip Pullman, P. D. James and

most significantly Colin Dexter have used it as a backcloth for their storytelling.

Let's take an Inspector Morse Tour of Jericho. This is especially pertinent as the *Morse*/Oxford/TV connection, 35 years long, may come to an end with the 'last' *Endeavour* series in 2021.

We start in Mount Place – the new public space in Jericho. Just by the Oxford Canal and down the stairs from the Bridge, it has recently been rescued from the anti-social by the city council laying York Stone with flower beds lovingly replanted by the group Greening Jericho. It used to be a tallow factory; today it is on the way to becoming a peaceful idyll for families with regular big weekend events like book and art fairs.

Down Canal Street to the first Morse connection. Combe Road. It features prominently as 'Canal Walk' in the first TV *Morse* episode, 'The Dead of Jericho', in 1987. This was not Colin Dexter's first book but when the TV people came calling they decided it was to be the first TV *Morse*. By the time they signed up Dexter – in an Oxford pub inevitably – they had done their research recces and decided Jericho it was to be. As ever the plot is not simple. Endeavour Morse wants to hook up with Anne Staveley who lives in Canal Walk. They share an interest in choral music. But she is reluctant and, as ever, there is a complicated back story.

Sadly, for Morse, she is found hanging in her kitchen at Number 9. Hers was not to be the last murder in 'Canal Walk' either. On more than that one occasion, Chief Inspector Morse and his faithful wingman Sergeant Robbie Lewis retreat to 'The Bookbinders Arms' across the road to discuss the case. Lewis pays. That pub is still there – similar on the outside. Inside is not as on the telly. Film crews' overtime did not come cheap then so interiors were filmed closer to the base or in a studio in Bray. Today, 'The Olde Bookbinders Ale House' serves good ale and even better food. Try it.

For spiritual replenishment, we proceed now along the canal to St Barnabas Church, also featured in *Morse*. Built in 1869 by the university printer Thomas Combe, it boasts a magnificent Italianate basilica inside. You will hardly believe your eyes. Well worth a visit.

At the end of Canal Street look out for No. 31 Nelson Street. Locals still talk of the night in 2008 when it was blown up by a film crew for *Lewis* reasons. They arrived, set up sound and vision, special effects, actors and prop police cars. Then they blew up the house and set it on

fire. All pretend, all special effects. It kept the locals entertained until the small hours. You can see it in series 2 of *Lewis*.

At the other end of Nelson Street, there's Jericho's own Gaza Strip. On one side, Al Shamir, Oxford's first Lebanese restaurant set up forty years ago by Momi who still presides. Across the road, a stone's throw away, the Oxford Jewish Centre, an ecumenical celebration of Judaism from the liberal to orthodox versions. On Shabbat (the Jewish Sabbath day), observe the 'synagogue securicor' closely eye-balling all who enter.

So we progress to Walton Crescent, up to Walton Street, recently the 'front line' in a controversy over a putative Low Traffic Neighbourhood scheme, and on to Little Clarendon Street (LCS). That features in the 'Death is Now my Neighbour' episode in 1997. It was once Oxford's 'little trendy street' where one of the main characters buys a dress for his unfaithful wife. After a hiatus and a nadir, LCS is now reborn with restaurants and wine bars and big street fairs. That and Walton Street surround Somerville College, the pioneer of higher education for women (including Margaret Thatcher) in Oxford and the site of the Southern General Hospital during World War One. Somerville features in *Last Bus to Woodstock* in 1988. That was the first Dexter Morse novel published in 1975 but only the seventh in the TV iteration in 1987. Somerville was also in 'Sins of the Fathers', in 1990.

Look out for the window of the magnificent Blavatnik School of Government, in Walton Street, founded in 2010 so too late to appear in any *Morse* episodes. It's a 'Marmite' sort of building – an architectural rounded masterpiece or a carbuncle, depending on your taste. I am in the former camp. Firmly.

Next door is the decaying edifice of the original Jericho parish church, St Paul's. It has ceased to offer altar wine and instead offers the real thing. Today, it is Freud Café Bar. Be wary, it does have rather erratic days of opening.

Behind that, the tower of the Radcliffe Observatory where, from 1772 to 1934, astronomers studied the stars in the night sky. It features in 'The Dead of Jericho', in 1987, and 'The Silent World of Nicholas Quinn' in the same year. Today, you can only go up by appointment to admire Jericho and north Oxford.

Across Walton Street stand the headquarters of Oxford University Press built like an Oxford college with a quadrangle. It employed 1,600

in pre-Covid days. That local 'word factory' supplies English language dictionaries and more to the world and makes a great deal of money for the university.

Along Walton Street to the Jericho Tavern. That features in 'The Dead of Jericho' but more importantly, for some, it was the petri dish in which the early careers of the bands Radiohead and Supergrass were incubated. Thom Yorke, main vocalist and songwriter for Radiohead, used to live just down the street in Kingston Road. His neighbours, sworn to silence at the time, told me.

Significantly, the Phoenix Picturehouse featured in *Morse* as Cinema Screen Two in 'The Silent world of Nicholas Quinn', in 1987. Morse goes there expecting to see Bernardo Bertolucci's risqué *Last Tango in Paris* only to be disappointed to find a more stolid film on show. Perhaps the Phoenix could pay homage to the most famous Oxford detective by featuring a season of *Morse* TV films?

A couple of hundred yards down Walton Street we come to St Sepulchre's cemetery as seen in 'The Wench is Dead'. Atmospheric does not describe the experience of this over-full graveyard. Amongst those buried here are Benjamin Jowett (1817-1893), Master of Balliol, and Henry Boswell (1835-1897), founder of a celebrated trunk and portmanteau shop.

We next make a quick u-turn back and then go right at Brasserie Blanc – the site for a small scene in 'Death is Now My Neighbour' – an outpost upon which the Raymond Blanc empire was built. Spoil yourself: the food is always good. Then down Juxon Street notice the houses are all the same on one side. Built by one builder but bought up by Lucy's who had a huge metal foundry at the end adjoining the canal. They wanted access for lorries to their loud and smelly works and no neighbours complaining.

The foundry has long gone to be replaced by the rather posh 'Lucy Flats' where the great and good of Jericho live: for instance, today Richard (*The God Delusion*) Dawkins and in the recent past the crime novelist P. D. James. A few other Jericho Streets have common frontages and identical colour exterior painting. They are usually owned by the same college. You do not need to be Endeavour Morse to work that out.

Finally, down Mount Street back to Mount Place. On a good sunny day you can see the social mix of Jericho there: social housing tenants to famous Oxford University professors. Some weekends you can catch

an event or two there with musicians playing on a canal boat and scores looking at and buying books or art.

Walk around Jericho. You don't need to be a famous detective to discover its secrets.

## Note on the Contributor

John Mair is a much-published author with more than 40 edited books to his credit. He is a former BBC producer and a Jericho resident.

# SECTION 2
## Colin Dexter: In the Beginning was the Word

# Introduction

John Mair

Colin Dexter, the author of *Morse*, was an interesting character to say the least. A Cambridge scholar, at first taught at a private school then relocated to Oxford when increasing deafness made that no longer possible. In Oxford, he worked for the Examinations Board on the ring road, became a crossword guru locally and nationally (the Morse name came from his fellow crossword aficionado Sir Jeremy Morse) whilst the Morse story gestated in his brain. They only came out on a wet holiday in North Wales. *The Last Bus to Woodstock* was the result. Twelve other Morse novels eventually followed.

The secret of the books and later of the TV series lay in the quality of the writing as well as the strength of the characters. Nobody ever doubted that with Dexter. In a revealing interview in 2007, he discusses the genesis and shape of the Morse character. It is reproduced here.

Dexter, like Morse, enjoyed his glass of ale until medical advice dictated otherwise. Christopher Gray, a fellow Oxford *bon viveur*, recalls afternoons in various Oxford pubs spent with Colin. Sometimes he paid. The Morse Bar in the Randolph Hotel is his lasting legacy.

What of his oeuvre? His editor Maria Rejt at Macmillan recalls the creative partnership that sometimes involved her red pencil and temporary tension. Dr Paul Davies, a literary scholar, dissects *Last Bus to Woodstock* as a piece of writing to discover the secret.

Finally, Cara Hunter the Oxford author of the 'New Morse' Detective Inspector Adam Fawley, already a best-seller and destined for the TV screens, recognises her debt to Dexter and Morse but also admits she was initially wrong not to place her stories in Oxford. Fawley's Oxford though is not Morse's. It is based outside the golden mile of the colleges in unfashionable suburbs like Cowley as she shows in her own Fawley tour map.

Dexter's Oxford detective legacy lives on...

# Chapter 3

## Dexter on Morse – and on Dexter

*Who better to outline Morse and his progression from one page to a worldwide screen success than his inventor – Colin Dexter. In a wonderful, 35-page booklet published in 2007, Dexter opens up about the character and about himself. Here are some extracts.*

### Genesis of the First Book – and a Holiday Ruined

It is not unknown, even in mid-summer, for the heavens to open in North Wales; and there are few things more dispiriting than to sit in a guest-house with the rain streaming in rivulets down the windows, and with offspring affirming that every other father somehow manages to locate a splendid resort, with blue skies and warm seas, for the annual family holiday. That was my situation one Saturday afternoon in August 1973. Having rather nervously asserted that we were *not* planning a premature return to Oxford, I shut myself up in the narrow confines of the kitchen with a biro and a pad of ruled paper – with only a very vague idea of what I was intending to do. I had already finished reading the two paperback detective stories left by previous guests, and I figured that, if I tried hard, I might possibly do almost as well in the genre myself. So, for a couple of hours I tried *very* hard. Resulting in how many paragraphs, I cannot recall. Yet I doubt more than two or three. It was, however, that all-important start: *Initium est dimidium facti* (the beginning is one half of the deed), as the Roman proverb has it.

My first work of fiction, *Last Bus to Woodstock*, originated on that day, and was finally published by Macmillan in 1975.

I had my manuscript typed up, with just the one heavily corrected and smudged carbon-copy, and asked around for the best bets among the publishing houses. Collins, Gollancz and Macmillan, in that order, topped the list. I had no agent (still haven't) and I posted the typescript to Collins – from whom, after a chivvying letter from me, I received a letter about four months later. It was a pleasantly argued letter of the kind that so many hopeful, budding authors have come to know only too well: an 'if-ever-you-write-anything-else' kind of letter. A rejection letter. So, leaving out my second choice, I parcelled up *Last Bus to*

*Woodstock* once more and sent it to Macmillan, a publishing house with, as I learned, an increasingly prestigious crime-list.

Within 48 hours I received a phone call from the senior crime-editor there, Lord Hardinge of Penshurst, asking me to get up to London post haste. He had read my novel and was prepared to publish it without further ado (and without alteration!) 'warts and all'. But I have ever stuck with Macmillan. And for over thirty years now successive crime-editors – George Hardinge, Hilary Hale, Maria Rejt and Beverley Cousins – have handled my literary affairs wonderfully well. I have been, let me repeat it, a very lucky writer.

I never allowed anyone, not even my wife Dorothy, to read my novels before they were dispatched to my publisher. It was only then that I was ready for any criticism. All writers, of course, will sometimes wince silently at some of their earlier offerings, and wish to amend them. I remember, for example, once having Morse enjoying 'a pint of the amber fluid' instead of 'a pint of bitter'.

### Why the Name Morse and Why Endeavour?

Chief Inspector Morse I named after Sir Jeremy Morse, a man with as sweet and clear a brain as I have known. He was a former chairman of Lloyds Bank, key member of the Bank of England and the IMF, Fellow of All Souls, Oxford, Warden of Winchester College, etc., etc., regularly parading his genius in chess problems and crossword puzzles. Indeed, it was in the crossword world where as early as the mid-50s we became keen competitors – and later good friends. And when I wished to introduce a detective-hero of consummate mental calibre, the surname was staring me in the face, was it not?

But just 'Morse' was not going to be wholly satisfactory henceforth, since some of the leading bookmakers had produced a list of odds, with 'Ernest', I believe, a common favourite. So, I had to come up with something, and I did. In previous novels I had informed my readers that Morse's mother was a Quaker, and that his father's great hero was Captain Cook. An examination of the New England Quaker lists threw up a variety of names – not just the familiar 'Faith', 'Hope' and 'Charity' but others, also enshrining comparable Christian virtues. And it was my wife Dorothy who discovered 'Determination' Davies and (yes!) 'Endeavour' Jones. Things had been settled then. I broke the news at the end of *Death Is Now My Neighbour*, whereupon Lewis was heard to mumble: 'You poor sod, sir!'

## The Place/Placing of Oxford

I had long envied the ability of some few writers, Simenon and Chandler in particular, to establish in their novels a curiously pleasing ambience of a city, a street, a bistro, etc. And I have ever hoped that the physical sense of Oxford, and the very spirit of the City, has permeated the pages in which Morse is summoned to so many (mostly fatal) scenes. Perhaps my one wholly legitimate claim to notoriety is that single-handedly I have made Oxford the murder capital of the UK – and probably of the EU.

Morse's city, described *passim*, lived in, and murdered in, is not *only* the city of great men – scholars, historians, poets, scientists, doctors, churchmen, etc – whose portraits hang proudly in many of the college dining halls used in the *Morse* episodes. Oxford is, and always was, the city of 'town' as well as 'gown'. And one of my proudest possessions is the following citation: 'The Lord Mayor and Oxford City Council place on record their appreciation of the literary talents of Colin Dexter who has been the most visual and the most watched novelist of our City. We are extremely grateful that in his novels he has shown our City as having a distinct and separate identity from its famous University.' I was a bit like Morse myself: quite certainly *in* the University, but not wholly *of* the University

The whole of my working life was spent in education: first, as a teacher of Latin and Greek in English grammar schools; second, with increasing deafness blighting my life, as a senior administrative officer with the Oxford Delegacy of Local Examinations, in charge of Latin, Greek, Ancient History and English.

## The Author as the Central Character

He [Morse] was in no way likely to be confused with the description I once gave of myself to a Finnish journalist: 'short, fat, bald and deaf'; on which the lady in question congratulated me warmly, saying that, because of this, she had recognised me 'immediately'!

Morse changes very little throughout the novels, betraying the same qualities in my first and, and as I thought at the time, my only one. He was, and remained, a sensitive and sometimes strangely vulnerable man; always a bit of a loner by nature; strongly attracted to beautiful women (often the crooks); dedicated to alcohol and almost always on the verge of giving up nicotine; in politics, ever on the left, feeling himself congenitally incapable of voting for the Tory Party; a 'high

church atheist' (as I called him), yet with a deep love for the Methodist Hymnal, the King James's Bible, the church music of Byrd, Tallis, Purcell, etc, the sight of candles and the smell of incense. Finally, like me, he would have given his hobbies in *Who's Who* as reading the poets, crosswords and Wagner.

He was quite unwilling to give thanks to any of his hard-working underlings (especially Lewis); had little or no respect for most of his superior officers; was unorthodox, with little knowledge of police procedure and only minimal respect for forensic pathology; often pig-headed; impatient; a man with alpha-plus acumen, normally six furlongs ahead of the whole field during any investigation, but so often running on the wrong racecourse.

And has there ever been a fictional detective so desperately mean with money? For example, in *The Remorseful Day*, the pair of detectives are the first customers in the bar of Oxford's Randolph Hotel at 11 a.m., and Lewis's eyebrows are raised a few millimetres when, throwing the car-keys to Lewis, Morse suggests that it's high time he, Morse, bought the drinks: a large Glenfiddich for himself and half a pint of orange juice for Lewis – only for the unfortunate barmaid to tell Morse that she cannot find sufficient change so early on for the £50 note proffered. Whereupon, patting his presumably empty pockets, Morse asks his sergeant if by any chance he has some appropriate small change on his person....

## Television Comes Calling

Fortunately for me, two very gifted men, each with huge experience in the TV world, were very much pro-Morse. After reading some of my novels, both agreed that the beautiful city of Oxford would be an ideal setting for a series of murders, solved by a lugubrious Wagnerian and his solid (never stolid!) sidekick, would be a potential winner.

At a meeting in a north Oxford pub, 'The Friar Bacon', Kenny McBain, Anthony Minghella and I drank a few pints of beer together and talked and talked of many things ... of which I remember only one with clarity. When I suggested that after lunch I would with the greatest pleasure show them around a few of the murder sites in Oxford which I had already used, McBain smiled and declined my offer: 'We've already visited them, Colin.' After lunch, half launched upon the shores of light was *Inspector Morse* that day. ('The Dead of Jericho' was transmitted in 1987.)

The biggest item of contention, as I recall, was the proposed one-night, two-hour, prime-time programming. I had thought that this was asking a little too much of our likely audience. I was wrong.

## Why was *Morse* a TV Ratings Success?

Wherein lay this good fortune? First and foremost it was undoubtedly in the casting of John Thaw and Kevin Whately as Morse and Lewis, with much of the credit for this resting with Ted Childs. [John Thaw] told me that he enjoyed playing Inspector Morse more than any other role, and for me that was an unforgettable compliment. I can just about understand why that great actor thought so. For me John Thaw *was* Inspector Morse. And in my will I have specifically stated that for as long as the copyright on the character remains with me, I shall permit no other actor to follow him. No other actor *could* follow him.

Second, with the string of distinguished screen-play writers, directors and producers ITV was able to enlist in the making of the thirty-three *Inspector Morse* episodes filmed. The big advantage of TV, of course, is that the viewer can *see* what's happening, and where it's happening. A very simple example would be the fabric of the city of Oxford. Whilst I may indulge myself for a couple of paragraphs on describing the effect of sunlight on the cinnamon-coloured stone of an Oxford college, TV can do it in a few seconds – and do it *better*.

## Morse: The End?

He died of natural causes – a virtually inevitable consequence of a lifetime spent with 'cigarettes and whisky', though not with 'wild, wild, women'. The cigarettes were always a problem, and Morse gave them up on innumerable occasions – usually every day. Alcohol, however, was a different matter, with real ale and single-malt Scotch his favoured tipples. Frequently, with Lewis, he sought to perpetuate the claim that he needed to drink in order to think and, indeed, there was clearly some justification for such a claim. Whisky, if drunk copiously, may have at least three possible effects: the legs may buckle, the speech become blurred, the brain befuddled. But Morse had no trouble with this last effect. His brain was sharper than ever, his imagination bolder, even his deep pessimism concerning the future of the planet a fraction modified. A longer-term effect was that his health grew worse, and he knew the score as well as any of the medical consultants whom Morse steadfastly refused to visit.

*This is an edited extract from Mysterious Profile 3 produced by the Mysterious Bookshop on New York. It is reproduced with permission of Otto Penzler, the publisher. The booklet was distributed at Colin Dexter's memorial service in Christ Church Cathedral, Oxford, in April 2018.*

# Chapter 4

## Drinking with Dexter

**Christopher Gray is the just-retired doyen of Oxford journalism. He served for many years in the salt mines of the Oxford Mail and Oxford Times. Among his contacts – and drinking buddies – one Colin Dexter.**

Colin Dexter's enthusiasm for beer – real ale especially – matched that of his great fictional creation Detective Chief Inspector Endeavour Morse. So, too, did his evident distaste for the painful business of paying for it.

The grumpy sleuth patting his (supposedly) empty pockets became a familiar trope in the television series *Morse*, with the put-upon Sergeant Robbie Lewis resignedly stumping up the necessary cash every time.

It was widely rumoured in Oxford's drinking circles that Colin himself usually preferred his ale to be at other people's expense. That this appeared to be the case was demonstrated to me during a long afternoon of tippling with him some 20 years ago.

The venue was 'The Turf Tavern', arguably Oxford's most famous pub, tucked away along a narrow alley beside New College. Presented (as 'The Lamb & Flag') in Thomas Hardy's *Jude the Obscure*, this historic boozer regularly featured in *Morse* which explains why Colin

was on excellent terms with its landlord. Colin was, of course, on good terms with so many landlords in Oxford, including those of the pubs closest to his Summertown home, 'The Dewdrop Inn' and 'The King's Arms'.

The latter always seemed to me to be a strange choice of watering-hole for one so admiring of the traditional. A modern plastic and chrome boozer – with lots of keg beers – it had nothing in the way of character. It is now a Chinese restaurant, 'The Dancing Dragon', which somehow seems a more appropriate role for the building. 'The Dewdrop', incidentally, is now the sole surviving pub in a swathe of Oxford stretching northwards from Hayfield Road to the ring road. Casualties include 'The Woodstock Arms', 'The Red Lion' and 'The Cherwell'.

## 'Left My Wallet at Home'

The accommodating landlord of 'The Turf' demonstrated his regard for the novelist on the occasion of our afternoon visit by offering us drinks 'on the house'. Other rounds were bought by me (twice), by my partner, Rosemarie, and – I think – by the young lady in Colin's company. She was a telephonist from the Thames Valley Police headquarters at Kidlington. Colin liked 'source material' close at hand. Throughout the hours of revelry, the one person not chipping in was the one best able, in financial terms, to do so, Mr Dexter.

Of course, we didn't really mind, because Colin was such an engaging companion with a fund of witty but never malevolent stories, some involving people I knew.

## Dexter the Puzzler

As a journalist on the *Oxford Times*, I had got to know him in the early days of his writing fame. As 'Codex', he was one of the team of compilers supplying the paper's crossword puzzle, recruited presumably by the editor, Anthony Price, himself a highly-regarded crime fiction writer. Like Colin, Tony Price was a regular winner of the various 'daggers' – gold, diamond and the rest – awarded by the Crime Writers' Association to its members. This always seemed to me (and to a few others) as being a curiously incestuous organisation composed of members regularly bestowing lavish praise in reviews of each other's work.

Colin himself can be absolved from any such accusation since, as far as I can recall, he ventured into print in newspapers and magazines very rarely and never puffing the works of his gifted contemporaries.

## Our Common Interests

One interest we shared, I was soon to discover, was opera (like Morse, Colin was hugely admiring of Wagner). Another was our scenes of childhood. Colin was brought up in Stamford, Lincolnshire, 14 miles from my home in Peterborough, I had an aunt and uncle well-known in the town. Colin's elder brother, John, taught classics to a number of my friends at Peterborough's King's School (I was at the rival grammar school half-a-mile away).

## Dexter in the Randolph

I spent many happy hours with Colin at the Randolph Hotel, the focal point for *Morse* filming over more than a decade – with stars John Thaw and Kevin Whately often present. The main bar was eventually named after the detective.

The hotel has a considerable claim to fame (did Colin know?) in the annals of true-life crime as the venue for the first amorous encounter between the middle-aged *femme fatale* Alma Rattenbury and her 18-year-old chauffeur George Stoner. The matter is dealt with in detail in a book, *Murder at the Villa Madeira*, on the famous 1935 murder case written by the celebrated solicitor, Sir David Napley. One or other of the pair had bludgeoned to death Mrs R's architect husband Francis. A death sentence on Stoner was commuted by the Home Secretary Sir John Simon, a Fellow of All Souls College, by which time the grieving Alma had topped herself. The best-known drama critic of the day, James Agate, writing for the *Daily Express*, compared her demise (preposterously) to the sinking of the *Titanic*. Terence Rattigan's final play, *Cause Célèbre*, addressed the matter. This was successfully revived at London's Old Vic Theatre, in 2011.

## Colin's Literary Adviser? The Barmaid

The 'chatelaine' of the Morse Bar was the wonderful Irish woman, Ailish Hurley, Colin's close friend, who was name-checked in his books and appeared on screen in the *Morse* television series. She famously persuaded Colin not to kill off Morse (as the writer had intended) in the 1994 novel *Daughters of Cain,* giving him five more years before his death in *The Remorseful Day.*

## High Speed Friendship

My oddest outing with Colin was in 2007 when we shared a table in a high-speed train to Didcot. What made it so odd was the make-up of the train – just one carriage flanked by two huge power cars. There was room for nothing longer on the side platform of Oxford station where Colin had unveiled the engine named *Oxfordshire 2007*. This was the only time I met Colin's delightful wife Dorothy. The railway setting prompted conversation between us on crime writing's 1930s Golden Age – in which trains often featured – and another Dorothy took a bow. Colin admitted a hearty dislike – which I partly shared – for the works of Oxford-born Dorothy L. Sayers, whose immense snobbery (knickers in a twist over her aristocratic sleuth Lord Peter Wimsey), he said, disfigured all her novels.

This was not an accusation that could ever be levelled at him or at his enduringly popular literary creations. Indeed, while the university milieu is often the focus of investigation for Morse, his attitude to it is far removed from the grovelling respect shown by many other fictional detectives.

## Note on the Contributor

Christopher Gray graced the pages of the *Oxford Mail* and *Oxford Times* for nearly half a century until putting down his pen in 2020. His arts diaries and restaurant reviews were staples of Oxford journalism. Nothing moved in Oxford without Chris applying the Gray Matter to it.

# Chapter 5

## Colin Dexter – A Personal Remembrance

Nobody knows an author better, however many copies they sell, than their book editor. Maria Rejt was Colin Dexter's editor at Pan Macmillan for many of his Morse novels. She recollects – and explains why she has never read the final novel in the series.

My name is Maria Rejt and I worked with Colin as his editor and publisher from August 1990 to September 1996 at his long-time publishing home, Pan Macmillan. Colin had submitted his first manuscript, famously conceived and written during a wet holiday in Wales, in 1975 to George Hardinge, the publisher who launched Macmillan Crime Case – a hardback imprint dedicated to publishing crime fiction. George read *Last Bus to Woodstock* overnight and made Colin a publishing offer the very next day. Colin remained with Macmillan for the rest of his writing career and he never forgot George Hardinge's faith in him.

During our time together Colin was retired from his examinations job and enjoying the huge success of John Thaw's *Inspector Morse* on TV, still one of the most successful and repeated crime drama series ever produced. But his first love remained writing and during our collaboration Colin wrote *The Jewel That Was Ours, The Way Through the Woods, The Daughters of Cain, Morse's Greatest Mystery* and *Death is Now My Neighbour.*

## How Colin Killed Morse

His final Inspector Morse novel, *The Remorseful Day*, was published in 1999 after I had left Macmillan to join Random House, and to this day I confess I haven't been able to read it: I know Colin writes Morse out of life and for me it remains just too sad to confront.

Colin always wanted to end Morse's life in the manner of his choosing. He once confided that the only disagreement he'd had with one of the regular TV writers of the series was when the writer told Colin that he had conceived Morse's perfect end: he was to die at the famous Wagner festival at Bayreuth, a bomb placed under his seat. I don't think the script writer had the time to explain why a bomb was to be placed there. Colin simply said no, because Morse was HIS character, and I suspect also because he saw Morse – for all his complex gifts – as an ordinary soul, and death by a Bayreuth bomb was certainly no ordinary death.

## *Endeavour:* A Great Marketing Touch?

Colin never made a secret of the fact that his Morse was mortal, too, and that one day he would decide how to write his last case. But the secret he kept from everyone for a very long time was the question of Morse's first name, only revealed in 1996 in the novel *Death is Now My Neighbour.* So, it was a secret he kept for more than twenty years. We knew the name began with the initial 'E' and many a fan was convinced the name had to be Ernie or Eric, Eddie or even Ernesto.

Before submitting the novel to me Colin wrote Morse's first name on a place card at an awards dinner and asked me to reveal it to no one. Some months later, *Death is Now My Neighbour* was published and Morse's first name – Endeavour – was reported on national news: the publicity surrounding its revelation ensured Colin a No. 1 spot in the bestseller charts. Without perhaps knowing it, Colin was a bit of a marketing genius, too.

## Oxford to the Core

If you think of some of the other very great Oxford novelists – J. R. R. Tolkien, C. S. Lewis, Philip Pullman – the great city doesn't feature in their fiction, or only tangentially, in Pullman's case, but it is very much the beating heart of all Colin's work. He even took inordinate delight in using the Oxford comma as much as possible and acute displeasure ensued if any eager copy-editor decided to take any of these particular punctuation marks out of his typescripts.

Colin loved inhabiting the fabric of Oxford both in life and on the page. Not much time is spent at Thames Valley HQ in Kidlington but a great deal in the city's pubs, famous and shabby, the beautiful colleges and popular hotels. Only exceedingly rarely does the inspector take a holiday, as he does at the beginning of *The Way Through the Woods,* in Lyme Regis: perhaps uncertain of his territory, Colin wrote a beautiful scene-setting passage about the flight of some seagulls above its famous Cobb. But the passage didn't fit the novel and I asked if he'd take it out. He told me that he considered it some of his finest writing and then, with a smile, promptly agreed to its deletion.

## E. Morse, MA (Oxon) Not Completed

I sometimes wish I had talked to Colin about why he chose Oxford for the backdrop to his fiction. People assume it is because he made his home there whilst working at the Oxford Examinations Board and remained once retired. But he had also been a Cambridge classics scholar, had loved his time there and I often thought Cambridge would have better suited the cerebral, introverted character Colin gives Morse. I don't think it's accidental that Morse never completed his degree at St John's, Oxford. He was to carry that chip throughout his life. My hunch is that Colin wanted him to be the classic outsider, fitting in with neither town nor gown, always aware that he had failed at the academic stuff, and needing to prove himself time and again.

But crucially, despite that failed academic record, he was better than the Oxford academic establishment with whom he so often parried and always won.

## Dexter and Camilleri

When thinking of iconic locations, another great crime writer comes to mind, the late Sicilian novelist Andrea Camilleri, whose last Inspector Montalbano novel, *Riccardino,* is due to be published here later this

year. The similarities between the two writers are evident: a huge love for the place in which they set their fiction, Oxford and Sicily, two maverick detectives, both 'commitment-phobes', often inspired by their love of food, alcohol and the opposite sex. And most crucially, a deep hatred of injustice married to an abiding sense that whatever happens the moral order will, if only briefly, be restored.

I knew Colin very well and had met Andrea Camilleri only once but they shared a shining humility and a joy for life that comes from appreciating the fragility we all live with, the sense that things can – and do – change in an instant.

## Not Deaf to the World

I think this appreciation is perhaps most evident in Colin's most autobiographical novel, and one of his best, *The Silent World of Nicholas Quinn*. First published in 1977, way before the TV people came calling, it is a supremely clever whodunnit. It is a classic crime novel in that it centres on a closed community, in this instance that of an Oxford Examinations Board, obviously a world Colin knew very well, and we learn very early in proceedings that a young man is appointed to the board only because of his disability. And, crucially, that he is profoundly deaf and can only hear what he sees.

His murder by cyanide poisoning at first just doesn't add up: he is punctilious, professional and good-hearted.

And without giving anything away for those who are yet to read it, Colin puts Nicholas Quinn's deafness at the very heart of how Morse comes to solve the crime. He shows us how a person with such a profound disability is forced to live and just how difficult life must be for them: in Nicholas Quinn's case, his deafness and the way he has adapted his life to it have caused his death and also given Morse the key to solving the mystery.

Colin's own deafness was, of course, the reason he had been forced to retire from teaching and then, as the condition worsened, his career at the Oxford Examinations Board. It was typical of Colin's optimism to use that bruising experience in such a positive way by making it the centre of Nicholas Quinn's world.

## *Morse* the TV Creation/Sensation

His optimism was also to inform his attitude when the TV executives came calling. He knew that TV drama was a different beast to the

solitary ways of the novelist: collaborative, risky and very expensive. So, from the start, he put his belief in the talents of Kenny McBain, who first saw the filmic potential of the novels, and Ted Childs, who became the lynchpin after Kenny's tragic early death. Two key decisions were made from the start. Each episode was to be a self-contained two-hour story, unheard of in those days, and Lewis was to become a much younger, less confident foil for the world-weary and cynical Morse. Because John Thaw had piercing blue eyes Colin also made that subtle change in his novels, changing the inspector's eyes from grey. Morse's car was also upgraded from a Lancia to a more photogenic vintage Jag.

The popularity of the TV version meant that the schedulers wanted more episodes in each series, increasing from the original three to four then five per series. But Colin didn't want to write his novels any faster so talented screen writers like Danny Boyle were commissioned to compose original storylines. Colin was always given the scripts to approve and his comments were always incorporated, a pretty rare event in the world of commercial television. But by then a very deep mutual trust had been established.

## Dexter Does a 'Hitchcock' in a Bit Part

It is one of the lovely touches that Colin makes an appearance; usually in a crowd, often in a pub like the Wolvercote Inn. But only once was he given a speaking part, and unfortunately he fluffed his lines so badly (only two words to speak: 'Mr Brewster'), that the invitation to speak didn't come again.

But the TV people always loved having him around and he was often seen drinking with the crew in one of his favourite pubs, 'The Eagle and Child', or bantering on set between takes with his great friend, John Thaw.

There's no question that the TV showed Oxford in all its impossible splendour and beauty to the whole world and we have Colin, in no small part, to thank for that. Tourism with Morse trails and Morse ale blossomed and Colin was awarded the Freedom of the City as an honour. Which meant that he could graze his cattle free of charge in Port Meadow.

## Did the *Morse* Franchise Die with Him?

The final episode was broadcast on 15 November 2000. The great inspector dies on screen and after 33 episodes it seemed that the TV

series had reached its natural end. But the appetite for this Oxford-based police procedural with very little procedure had not waned and so two spin-offs were born: *Lewis*, again starring Kevin Whateley in the title role, and then more cunningly *Endeavour*, which we would now call an 'origin story', as young Morse climbs the ranks with the help of Inspector Thursday and a legend is born.

Colin again put his trust in the expertise of the television executives. He needed a little more convincing this time around as both series proposed exploring new territory. But he realised how many people's jobs were dependent on the shows, and I think this is what swung it for him.

So what of Colin's legacy? For Oxford and for readers it is undoubtedly immense. As a novelist he gave us crime fiction of the highest order, each book imbued with both ingenuity and humanity. His body of work has already taken its place in the pantheon of the greats. And as for Colin the collaborator and friend, his wisdom, humour and generosity gave those who knew him an extra skip in their day. And for that there is really no need for remorse.

*First delivered at St Hilda's College, Oxford, on 14 August 2021. Reproduced with their permission and that of the author.*

## Note on the Contributor

Maria Rejt has worked as an editor and publisher for nearly forty years and, in addition to Colin Dexter, she has published many other bestselling authors including Andrea Camilleri, Sue Grafton, Donna Leon, Kate Morton, Kate Mosse, C. J. Sansom, Laura Shepherd-Robinson, Jane Smiley, Scott Turow and Minette Walters. She now runs Mantle, her own imprint at Pan Macmillan.

## Chapter 6

## What was it about Last Bus to Woodstock that established the Morse novels?

In the beginning was the word. Colin Dexter's words. They started on a wet holiday in North Wales. *Last Bus to Woodstock* had a bumpy start but was eventually published in 1975, the first of thirteen Morse novels. Paul Davies subjects it to some literary analysis.

A first reading of Colin Dexter's first Morse book, *Last Bus to Woodstock*, is a puzzling affair. It's not just that there is naturally a mysterious crime in the book and that Morse himself is such a difficult, enigmatic person. There had to be something more to the book which made it stand out. So what did the original publisher Macmillan see in the book – and what did the first readers make of it?

It's difficult to recapture the difficulty behind those questions after the television series and our exposure to the John Thaw characterisation of Morse. On screen, as the accomplished actor he was, Thaw creates something more than we usually get from reading the novel or from thinking about the script. There is depth and pathos about Morse in the novels, but these two qualities are front and centre-stage in the television series. We see a great deal of thinking but what is being thought is largely withheld from us and that is so true to the novels.

Reading that first *Morse* novel I had a sense of foreboding and I think that's a clue to the success of the book. In the novel we have the underlying feeling almost from the very start that if the love-less Morse is going to find some sort of human warmth in one of the female characters, this will end extremely badly. After all he is friendless, self-absorbed and idiosyncratic in his likes and dislikes, he lives on his own and it's difficult to imagine anyone putting up with such a person who has aged into a lonely, egocentric character – so when, rather inexplicably, a woman finds him attractive, as in *Last Bus to Woodstock*, it just doesn't feel the relationship can go anywhere.

## Despite the Obstacles...

There are so many difficulties that Dexter puts in the reader's way that it feels strange that it became so popular. There is virtually no interior monologue explaining what is going on in the characters' minds, certainly not in the mind of Lewis and hardly at all even in the case of Morse. The most we get is usually a description of the individual's mood – quite often it's anger or irritation – and perhaps some indication that the character is thinking. We are held very much at arm's length even from Morse himself. In fact, apart from occasional insights into, for example, how Morse addresses a crossword clue and understanding that he has a headache or hasn't had enough sleep, very little of the solving of the crime mystery occurs in plain sight. That in itself should make the book difficult to find satisfying as we don't actually learn that much about the character beyond what we know on the surface.

Even the idea, presented quite often, that Morse is a curmudgeon is not that consistent. He is given to having outbursts, particularly at his colleague Lewis who, like us, can't quite understand why this has happened at any particular moment, and yet the curmudgeon in him is very quickly shown to be a passing mood – usually followed by having

a drink with Lewis to make amends, but not so far as to give an apology.

There is also a progression of facts that usually don't tie together and, in fact, raise more issues about the facts we already know each time a new one occurs. There is a general sense that Morse is making some sort of progress – and yet rather frequent descriptions of Morse beating himself up for not realising something immediately. There is never a straight line in the plot from one event to the next, but always a sense that *it isn't quite as simple as that*. The reader is kept very much on the outside of all of that.

## Only Morse – The Rest are Liars

The subsidiary characters – that is the likely suspects and their immediate circle – are mainly sketched in lightly. We learn about height, sometimes weight, colour of hair, a bit about mood, and if the character is female, we do learn whether they have attractive legs. There is not much sense of presence. They often feel like props and bits of scenery that can be moved around, usually in a confusing way. But their main characteristic is that they are liars – ranging in capability from those who don't tell the whole truth to those that just tell enough truth to disguise the farrago of lies that they have introduced.

We know they are lying because Morse himself believes that everything he is told is a lie, which is a useful attribute clearly in a detective, but makes it more difficult to read easily. We have no solid ground apart from the locations and the time of day (usually), and a sense of unease about even those some of the time. The time of day when some event occurs is always presented as a fact that Morse relies on at least for a while but even that time is generally more or less immediately questioned.

The relationship with any sense of a working day – probably very realistically – is particularly thin. It becomes a difficulty for the reader even when having each calendar day registered, because actually there are gaps – so what is going on in those gaps? – and also the day seems to extend beyond a reasonable twelve hours. We are often told that Morse is very tired, as well he may be, and that through tiredness his ability to figure things out is much impaired. In fact, as we later find out, those gaps and the apparent cognitive failures are where much of the crime solving goes on.

The relationship with Morse's superiors is best characterised as a one-way grudging respect which, apparently, doesn't mean that Morse has

to brook interference. We are told Morse doesn't do reports. How come? We are told that while on duty – when is he not on duty? – he is frequently having all sorts of alcoholic drinks, starting quite early in the morning. These may seem endearing qualities at one level – at another, it seems irresponsible.

It is highly anarchic and tolerated only because he gets results. That seems very far-fetched, although that's not so obvious when reading the novels because we do see that part of Morse's world through his eyes or, actually, it is presented with no comment and no criticism.

## Why So Popular?

I could go on to explain further why the novels are such a puzzle to someone trying to work out their popularity. The vocabulary isn't that forgiving. *Vox auctoritatis* is unusual even for the *Morse* books but not unexpected after a while, especially given a *synoptic whole*. Morse's grammatical pedantry sounds very much like Dexter's own, even down to the mention of *Fowler's Modern English Usage,* and perhaps well beyond the interest of most readers. Dexter's sentence construction is highly mannered and sophisticated and while it is easy enough to read without stumbling, it is not always clear at first reading.

Yet, the books are popular, sell in their millions and are read by a wide cross-section of the public apparently. So, what is the key?

The end of the book is one answer, but to get to the end of the book there must be factors early on to get over the issues I outlined above. We are plunged straight into the action and although this may be confusing – who is this person or who are these persons? – it is immediate and engaging.

There are, of course, the locations which are substantially based on real places in and around Oxford. For those of us who know Oxford reasonably well, it's rather good to picture these places. and leads me at least to wonder whether Morse, for example, could take the 15-minute walk so easily from the Radcliffe Camera to St Giles, especially with a gammy ankle.

What for those who don't know Oxford and Oxfordshire? There is a general sense in Dexter's target audience that Oxford is an interesting, ancient, and intriguing city. From at least Jude Fawley, in Thomas Hardy's *Jude the Obscure* (1896), onwards Oxford has a dreamy attraction and a romance. The use of these real locations which can be

traced on a map adds a quality to the novels. But this is hardly more than an ancillary – though attractive – element in the books' appeal.

The intellectual games and references that Dexter plays out in the novels are also a lure for some people – including me. 'A policeman's parking lot was sometimes not an unhappy one' is great for Gilbert and Sullivan people, for example, and even the mention of the *Listener* crossword is rather pleasing and obscure – and reminds me that once I did manage to do a few clues and several times I did understand the rubric. I'm sure this appeals, but not necessarily across the board.

I found these rather superficial elements of the novel did keep my interest and it is relatively easy to read his sentences, and the plot does move on quite quickly. That seems sufficient to keep the reader's interest.

## Crime Fiction – Is it Real Fiction?

Judging crime novel by the standards we'd apply to other works is probably not rewarding although this is not to suggest that this makes them inferior. In such novels we forgive any amount of difficulties with *understanding* the plot. Those of us who cut our reading teeth on Raymond Chandler will know that we just suspend disbelief about holes in a plot and accept that it probably hangs together – without anyone ever being able to precis the plot of, for example, *The Long Sleep*. This is not to suggest that the plot is unimportant, only that its minutiae are not most people's concern.

What Dexter does, cleverly, is to make Morse summarise the plot at the end – with all its ins and outs. It's like a real-time exposition as Morse takes us down even the wrong rabbit holes that he has been in, but drives through to the answer. It sounds crude but it isn't – and it is tremendously satisfying with quite a few 'Oh I see' moments. It leaves the reader at the end of the novel feeling that it was at the very least worthwhile.

I still don't think this answers my questions.

What makes the *Morse* novels work is a combination of all these points but the really important facet of the novel is that at its heart the author has a fondness for his characters that makes Dexter's work particularly attractive. Morse isn't a lovable rogue, isn't a successful womaniser, isn't a great wit, has eccentric tastes that are inexplicable – but Dexter rather likes him, making me wonder how much of the character is Dexter. There is a good feeling about that, and once we have had the

chance to understand the plot and feel comfortable about it, that's the abiding impression.

I wondered at first whether I would have wanted to publish *Last Bus to Woodstock* as a first novel with no idea of the vast hinterland that Dexter would create later. I just hope I would have.

## Note on the Contributor

Dr Paul Davies is the founder and now chairman of Bite-Sized Books and the author of a range of business books, including *What's This India Business?* And *Contract Management for Non-Specialists*. He has a PhD examining the novels of George Eliot and after teaching joined the IT industry before setting up his own consultancy, Onshore Offshore Ltd, which was focused on outsourcing and offshoring. The consultancy built on his experience of being CEO of a US IT company's subsidiary in India, and his experience managing companies in Singapore, Oman and the UK. He now lives in Oxfordshire.

# Chapter 7

## In the Shadow of Inspector Morse – Writing New Crime for the Old City

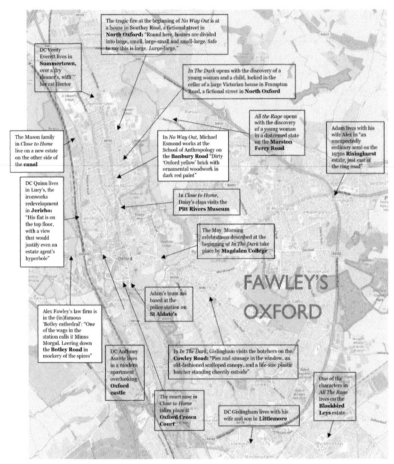

The tragic fire at the beginning of *No Way Out* is at a house in Southey Road, a fictional street in **North Oxford**: "Round here, houses are divided into large, small, large-small and small-large. Safe to say this is large. *Large-large*."

DC Verity Everett lives in **Summertown**, over a dry cleaner's, with her cat Hector

*In The Dark* opens with the discovery of a young woman and a child, locked in the cellar of a large Victorian house in **Frampton Road**, a fictional street in **North Oxford**

*All the Rage* opens with the discovery of a young woman in a distressed state on the **Marston Ferry Road**

Adam lives with his wife Alex in "an unexpectedly ordinary semi on the 1930s **Risinghurst** estate, just east of the ring road"

The Mason family in *Close to Home* live on a new estate on the other side of the **canal**

In *No Way Out*, Michael Esmond works at the School of Anthropology on the **Banbury Road** "Dirty 'Oxford yellow' brick with ornamental woodwork in dark red paint"

DC Quinn lives in Lucy's, the ironworks redevelopment in **Jericho**: "His flat is on the top floor, with a view that would justify even an estate agent's hyperbole"

In *Close to Home*, Daisy's class visits the **Pitt Rivers Museum**

The May Morning celebrations described at the beginning of *In The Dark* take place by **Magdalen College**

FAWLEY'S OXFORD

Alex Fawley's law firm is in the (in)famous 'Botley cathedral': "One of the wags in the station calls it Minns Morgul. Leering down the **Botley Road** in mockery of the spires"

Adam's team are based at the police station on **St Aldate's**

DC Anthony Asante lives in a modern apartment overlooking **Oxford castle**

In *In The Dark*, Gislingham visits the butchers on the **Cowley Road**: "Pies and sausage in the window, an old-fashioned scalloped canopy, and a life-size plastic butcher standing cheerily outside"

One of the characters in *All The Rage* lives on the **Blackbird Leys** estate

The court case in *Close to Home* takes place at **Oxford Crown Court**

DC Gislingham lives with his wife and son in **Littlemore**

*Map Courtesy Cara Hunter*

Cara Hunter, author of the highly popular DI Adam Fawley series set in Oxford, tells how her central character evolves into something much more than just a 'negative' of his famous predecessor.

Mid-way through his novel *The French Lieutenant's Woman*, set in Lyme Regis, John Fowles talks about how he 'came under the shadow

of a great novelist who towers over this part of England of which I write'. Thomas Hardy, of course. And I know how he feels. Only in my case the shadow isn't so much a novelist as the character he created, one who by anyone's estimation does, indeed, 'tower over this city of which I write'.

A whole shelf-load of writers had set their crime books in Oxford before Morse came along, but after what you might call AD – not 'anno domini' but 'after Dexter' – well, trust me, that's a whole different matter.

And let me say straightaway, I've always been the most massive *Morse* fan. The TV series was ground-breaking in its day and the character of Morse blossomed in the capable hands of John Thaw (though perhaps 'darkened' is a better word, since he's a good deal grumpier on screen than he was on the page). And for anyone who lives or has studied in Oxford, there's the additional pleasure of location-spotting (and opining to anyone who will listen that 'you can't get to Christ Church by walking up St Giles...')

If you watch re-runs now, the series still holds up remarkably well – forensics has moved on, of course (DNA would have killed a story like *Greeks Bearing Gifts* for a start) but the writing and the characterisation have definitely stood the test of time. As, of course, has the setting. Indeed, even 30-plus years later, Oxford is defined by the Morse franchise, both topographically and in the popular consciousness: there are guidebooks, walking tours, location handbooks and, yes, the pubs *still* market themselves as 'Morse drank here...'

All of which beggars the question, is there any room – metaphorical or otherwise – for anyone else? Is there some corner of this much-murdered city that another writer can hope to occupy?

Well, I confess, my instinctive first response was to try to swerve the issue altogether. I was convinced that after *Morse*, *Lewis* and *Endeavour* everyone would just be completely 'Oxforded out'. So the first version of *Close to Home*, the first in my DI Adam Fawley series, wasn't set in 'Oxford' at all. I mean, of course, it was set in the city really, I just called it something else. I had quite a lot of fun thinking of names, actually, settling eventually on 'Kingstead'. A reference to the fact that the city was Charles I's HQ in the civil war. Hence 'King', and 'stead' from the Anglo-Saxon for 'place'.

I had even more fun with Cowley, renaming it 'Car-stow': stow as a suffix means 'place of assembly'. Though I'm pretty sure the Saxons didn't have a BMW assembly line in mind...

But it was all to no avail. As it turned out, when I met my editor at Penguin, Katy Loftus, almost the *first* thing she said to me when we first met was: 'This is Oxford, isn't it?' So that was my career as a master of disguise crashing and burning before it even got off the ground...

What was I going to do next? Beyond hitting the 'find and replace' key, of course.

I should say right now that Katy was absolutely right – setting the books in Oxford has made them hugely more appealing and intelligible to readers around the world, and if Fawley has been translated into 25 languages so far, the star quality of this city has definitely played its part.

But I was still left in a quandary: if you're going to write new crime for this old city, how *do* you solve a problem like E. Morse?

## Let's Start with the 'Who'

I think it helped that I didn't start out with the aim of writing a police procedural centred on a single detective. The idea for *Close to Home* came to me first as the final twist (which I'm not going to give away!). But having got that idea, the challenge was, in effect, to 'work backwards': to develop a story – a family and a community – that would make that twist both a complete surprise and, at the same time, completely logical.

So it was in many ways more 'psychological suspense' or 'domestic noir' than it was police procedural. But because it's a story about a missing child, a criminal investigation was always going to be a central component of the plot. And to start with, that's all Adam Fawley was – a piece of plot machinery, albeit a pretty important one.

Crucially, the book was never 'about' him – I didn't know it would even be published, never mind turn into a series, so I didn't write it that way. I never thought about him as being a character who would have a life beyond one book. Once I did start to write Fawley, I admit that in the early versions he was shaped primarily by fear: I was so afraid he would be 'too like Morse' that he started to evolve 'in opposition to' Morse. He began as being what Morse isn't – his negative if you like.

He wasn't single, wasn't childless, wasn't a loner, wasn't an intellectual, wasn't much of a drinker, wasn't particularly fond of classical music, and wasn't particularly bad-tempered. And, as he himself says, very early on: 'While I'm at it, the car is a Ford. In case you were wondering. And I don't do bloody crosswords either.'

Speaking of crosswords, I do include a small homage to Morse in the name of my feisty and very definitely *female* detective Erica (E.) Somer, which the sharp-eyed among you will immediately have spotted is an anagram. But five books on, Adam Fawley has become much more than just a negative of Morse: he's not an intellectual, but he is bright and he did go to university; he's not bad-tempered but he can have a short fuse; he's not a drinker, but he does like a glass of wine (Merlot for preference); he's not a loner, but he is a very private person; he's in love with his wife but it's a marriage damaged by a tragedy not of their own making.

In five books, he's become his own man, with a personality and a childhood that I hadn't visualised (or even realised) at the beginning. And he even has a fighting chance of making it on to the screen himself one day. Fingers crossed...

## Next up: The 'Where'

In Morse, 'town' is pretty much synonymous with 'gown'. But as someone who was there as a student ten years earlier than the TV series, the university of Morse was always rather a chocolate-boxy version of the real place (one of my pet peeves both then and now is the way both dons and students are always depicted wearing gowns for tutorials – that was long gone even by my time, and yet the TV series carried on doing it right through to *Lewis*). And I always used to wonder how the 1990s university ever managed to teach anyone, given how many dons were bumping each other off behind the arras...

But joking apart, safe to say, the university has had its fill of murders. And given Morse does that so well, what's the point trying to compete?

*Close to Home* was never a university story anyway, but when Penguin commissioned more books, I made the deliberate – and very conscious – decision to avoid anything spire related.

As the city council's 'Inspector Morse City Trail' shows, the Morse books tend to revolve, literally, around the centre of the town. But 'Fawley's Oxford' is the opposite: I stand, so to speak, in the centre of city and look outwards. I 'turn the camera the other way'. So mine is

definitely *not*, as the *Irish Times* put it in 1999, 'the Oxford where a certain kind of England comes to die'.

Fawley's Oxford is darker, edgier, more real – a city of contrasts, focused on the very different communities that ring the city. From leafy North Oxford where the classic red-brick Victorian houses are 'divided into small, large, large-small, and small-large' to the west and Seacourt 'cathedral' 'leering down the Botley Road in mockery of the spires', to the south, and Blackbird Leys, and the east, to the Cowley Road, which, as Fawley observes, 'has always gone its own way, and the Victorian developers who tried to turn it into a lucrative mini model of its grand northerly neighbour quickly found it wouldn't take'. It's where these communities overlap those tensions arise, and as every crime reader – or writer – knows, that's where the stories are.

## Talking of Stories: The 'How'...

The final piece of the puzzle is the plot: the 'how' of a crime book – the story, and the way you tell it. The Morse books are very conventionally written, and likewise the Morse dramas are very conventionally structured. The books are almost Victorian in their formality: prologues (some even called 'Prolegomena'), then the narrative, often divided into books, then subdivided further into chapters, each with its own literary epigraph. George Eliot would be proud (and as a former English student I say that absolutely without irony)

And the TV is pretty traditional too. One strong linear narrative, very few flashbacks, a consistent single point of view. It's the broadcast equivalent of a 19th-century third-person narrative. It's also very different from much of the cutting-edge crime drama being made today. A show like *Line of Duty* doesn't just have extremely complex and demanding plots but an incredibly pacey presentation with lots of short intercut scenes and different points of view.

And that's what I've tried to emulate in the Fawley novels. There are no chapters, no division into books – in fact, I've done all I can to 'break the fourth wall': to give my reader the sense that this is 'really happening'.

So, not only does Adam speak directly to the reader (as in the comment about crosswords just now), the reader is also regularly given 'unmediated' access to documents and other source materials relating to the case, so that they can become detectives in their own right, working alongside Fawley's team to analyse and decipher the crime (and judging by the feedback, this is something my readers really love).

There are interview transcripts, WhatsApp and texts, body diagrams, blog posts, a fire scene report and crime scene drawings (the one in *In the Dark* and was drawn for me by a real-life CSI). There are maps, too, and yes, there are maps in Morse sometimes as well, but these are always placed where you would conventionally expect to find them – at the front. So even on the page, and certainly in the reading, a Fawley book is a very different experience from a Morse.

Another crucial aspect of this drive for a strong 'reality effect' is my slavish attention to authenticity when it comes to police procedures and investigative processes. To cite just one small example, police in the UK have never, as far as I know, worked in pairs, as Morse and Lewis do (and as they do in the US). It's always been a team effort.

There was a lovely anecdote from Val McDermid in the *Guardian* obituary for Colin Dexter in 2017: early in her career, when she'd told him she was anxious about 'getting it right', he just replied 'Well, my dear, I had written five Morse novels before I had even set foot in a police station.'

And it worked – of course it did. And brilliantly. But I hope that by taking such a very different approach I've managed to find room for another detective in this wonderful city, and another way to write decent crime.

Who knows, maybe one day they'll be doing DI Fawley tours.

You can but hope...

*This was originally given as a talk for St Hilda's Crime Fiction Weekend, 2021.*

## Note on the Contributor

Cara Hunter is the author of *The Sunday Times* best-selling crime novels featuring DI Adam Fawley and his Oxford-based police team. Her books have sold over a million copies in the UK alone, and been translated into 25 languages so far. Her third novel, *No Way Out*, was selected by *The Sunday Times* as one of the 100 best crime novels since 1945. Her first novel, *Close to Home*, sold over half a million copies, was a Richard and Judy Book Club pick and was shortlisted for Crime Book of the Year in the British Book Awards 2019. The fifth book, *The Whole Truth*, was a Richard and Judy summer pick for 2021. The TV rights to the series have been acquired by the Fremantle group.

# SECTION 3
## Morse the Copper

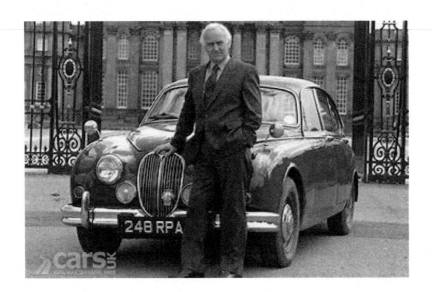

# Introduction

John Mair

Colin Dexter was not a policeman; indeed, he had rarely graced the inside of a police station before writing *Morse*. He allowed his imagination to roam inside the walls of St Aldates and Cowley nicks. How accurate was his portrayal of Oxford policing?

Peter Neyroud should know. He was the Chief Constable of Thames Valley Police which had swallowed up Morse's Oxford City Police. Neyroud, like Morse, is a Classics scholar. He tells a very amusing story about quoting Homer's *Iliad* to open-mouthed fellow officers. One can only suspect they did not go to source to find out more.

Like Morse, he too is thoughtful about policing. Indeed, he has a doctorate in it and now teaches at the University of Cambridge. Neyroud examines the runes of the *Morse* franchise and finds some of Morse's practices would not stand the test of time. Modern policing technology like DNA would have out-foxed even Inspector Morse. Neyroud himself has left a Morse legacy in Oxford – the blue plaque outside the main police station. That has proven to be a double-edged sword attracting the eyes and cameras of passing tourist buses. The natives at one point put a cardboard cut-out in the window visible from the open top deck with the legend 'Morse's office'.

Dermot Norridge got down and dirty as a Detective Sergeant then Inspector on the streets of Oxford. Does he think Morse is the real deal as a policeman? Well partly. He thinks Dexter may have got some of the characters right as did later writers with Fred Thursday and Reginald Bright but only sometimes the procedures. He also reveals the hidden pride the Oxford force had in living in the reflection of *Morse* the book and the television series.

Inspector Morse did not only put Oxford on the map, he put Oxford policing there too.

Chapter 8

# Inspector Morse: Real or Fiction?

How true to life was Colin Dexter's original creation (and
those who followed on screen)? Always ask a policeman.
A local one. Who better than Peter Neyroud, CBE, QPM,
the former Chief Constable of Thames Valley Police
(Morse's patch), then 'Policing Tsar', now teaching
criminology to senior police officers
at the University of Cambridge.

In 2002, as the new Chief Constable of Thames Valley (and a
committed fan of the Colin Dexter novels), I agreed to put a blue
plaque celebrating Inspector Morse on our police station at St Aldates
in Oxford. The initiative arose from a dinner conversation with Colin
Dexter. For me it was a little bit of harmless whimsy. For my detectives
working in the police station – one could say Morse's real-life
successors – his plaque turned out to be a curse. Day after day they
now had to endure the (open top) tourist buses stopping to inflict the
same commentary about their famous, fictional colleague.

## Morse and Me

Fictional or not, Morse has been a real presence for many British police
officers, especially if you happen to be an Oxford-educated police
officer with a love for classics. I did Classics and History of Art at
Winchester College and then read Modern History at Oriel, Oxford,
one of the colleges which has featured prominently in all three of the
series: the original *Morse*, the follow-on *Lewis* and the prequel
*Endeavour*. I knew a lot about Homer and Anglo-Saxon England. I
even treated an astonished room full of my officers to a few verses of
the *Odyssey* in Homeric Greek to mark a particularly beautiful sunrise
over Southampton Water: '... when rosy fingered dawn rises in the East
... over the wine dark sea.' The Aegean may be more 'wine dark' than
the Solent, but dawn spreading across the water and towards the New
Forest does have a Homeric quality on an early turn!

## The Copper as Intellectual – and Vice Versa

I could, therefore, empathise with Morse and his experience of the antipathy displayed by some of his on-screen colleagues because Morse liked opera and was far too clever. I can vividly remember as a young constable being rudely awakened in the middle of the night by the detective chief superintendent bursting into my section house room with the encouraging words: 'You are the bloody bright bastard; I need you now!' He wanted someone to read through several hundred pages of statements to sort out the key actions for a double homicide. It could have been a scene from *Endeavour*.

When I first became a detective superintendent and found myself handling a particularly difficult multiple murder, I overheard one of the detective constables telling his partner: 'And look what we got ... Morse and bloody Lewis.' The latter was a reference to my deputy senior investigating officer, who was neither a Geordie nor in any other way like Kevin Whateley, the loyal sidekick, other than being a first-rate detective. Either way, Morse and Lewis appeared to be very much alive for those detectives.

## Murder Most Foul Then and Now

However, late 20th and early 21st century homicide detection does not look much like the early Morse cases. Modern investigation is centred on digital and DNA forensics, CCTV and Automatic Number Plate Recognition. A modern murder incident room has more of the characteristics of the White House Situation Room than the dingy metal-desked hutch that greeted Morse and Lewis every day.

Two detectives driving around in a vintage Jaguar solving the case by interviewing the small cast of potential suspects is fiction, not fact. Furthermore, if you believed those early series then, rather like *Bergerac*'s Jersey or, more recently, Jimmy Perez in the Shetland Isles, Oxford colleges were the most extraordinary of homicide hotspots. The reality is more prosaic and the real Thames Valley crime scenes are very short on stunning country houses.

## Why was Morse Such a Good Detective?

What remains common between the *Morse-Lewis* series and the modern-day detective is the passion to solve cases and prevent bad and dangerous people getting away with murder. You only have to listen to the stories of Colin Driscoll, the Detective Chief Inspector who

finally brought Stephen Lawrence's killers to book, or DCI Colin Sutton, who caught Millie Dowler's killer, to realise that at the heart of the *Morse* stories lies a truth that Colin Dexter understood, and the series illuminated brilliantly. Murder is and will always be our most serious crime. In a world where values can seem all too relative, the detection of murder, both real and fictional, provides a certainty and fixed point that is worth celebrating. In that sense alone, Morse has always been more real than fiction.

It is a credit to his creator, Colin Dexter, that Morse has endured and will continue to endure, because he is much more than a just a product of three ages – the '50s and '60s for *Endeavour*, the '70s and '80s for *Morse* and the '90s and noughties for *Lewis*. The US academic, David Alan Sklansky, has said that one of the most important things we want from a police force in a democratic society is to believe it will stand up to the powerful and be on our side. Morse and his alter ego Endeavour and Lewis seem to me to embody those very qualities of independent bloody-mindedness and determination. That, as Morse might say, is worth raising a pint to (or may be several).

## Note on the Contributor

Dr Peter Neyroud is an Associate Professor at the Institute of Criminology, University of Cambridge, and former Chief Constable of Thames Valley Police. Peter joined Hampshire Constabulary in 1980, rising through the ranks within Hampshire to Detective Superintendent. He was appointed Assistant Chief Constable of West Mercia Constabulary in 1998 and reached Deputy Chief Constable two years later. He was appointed Chief Constable of Thames Valley Police in 2002. In 2006, he set up and then led the National Policing Improvement Agency – becoming a Policing 'Tsar' and adviser to the government. He left NPIA in 2010 to complete a PhD at Cambridge exploring how to improve policing with experimentation in new methods. He now teaches senior police leaders from across the globe. One of his best friends at Winchester and Oxford was Richard Morse, son of Sir Christopher Jeremy Morse, banker and crossword solver, after whom Morse was named.

## Chapter 9

# Inspector Morse – The Real Deal Oxford Policeman?

**Endeavour Morse is Oxford's most famous policeman but how accurate is Colin Dexter's character? Inspector Dermot Norridge was in the Oxford City Police for over two decades. Does he recognise Morse as the real thing?**

I first became aware of the *Morse* TV series as a serving policeman when I moved to Oxford in 1986. At that time I had never heard nor read any of the novels by Colin Dexter on which the programme is based. I subsequently purchased all of the books and read them with great interest.

## In Step With the Police...

By then, the filming had begun with the producers liaising with senior police officers at the headquarters in Kidlington and at St Aldates Police Station, Oxford. There was clear cooperation as the producers were allowed to use the name 'Thames Valley Police' and were provided with force documents and forms bearing the Thames Valley Police symbols. Avid *Morse* viewers will note that in an early episode, Inspector Morse can be seen leaving St Aldates Police Station in his distinctive Jaguar. The station has since been redeveloped and the entrance then used has long gone. It is also noticeable that the uniform officers can be seen wearing are custodian hats similar to those used by the force with the letter 'B' next to the officers' numbers on their epaulettes. This signifies the 'B' division of Thames Valley Police which included Oxford. It is a shame not more use was made of the St Aldates Police Station. It is a wonderful building constructed in 1937 with many art deco features inside and out.

## Or Not...

Such cooperation in later episodes was watered down and eventually the producers were not allowed to use the Thames Valley Police name and, instead, viewers were introduced to 'the Oxfordshire Constabulary'. Force mergers occurred creating the Thames Valley Police force. Before that, Oxfordshire Constabulary covered the county

of Oxfordshire but not Oxford City which had a separate force with its headquarters at St Aldates.

## Mixing with the Force

In the early years, the producers and certain actors would attend the police bar situated on the ground floor at Oxford Police Station – each major police station within Thames Valley would have a police social club. These have long since disappeared. I recall a jovial remark by my then-detective inspector to John Thaw in the St Aldates bar: 'So you are playing me?'

With the back drop of the City of Oxford and its superb architecture, intriguing plots and good scripts, the *Inspector Morse* series took off and for many years it was popular viewing. It has continued to be so – particularly with the development of the sequel *Lewis* and prequel *Endeavour*.

## Filming and Oxford

My first inter-reaction with the producers and crew was when certain props were stolen from a hotel room in North Oxford where they were staying and had based their operations.

There were regular sightings of filming taking place in the city. In the early episodes there were many scenes easily recognised as Oxford. Some included crowds, the producers obviously feeling confident in doing so. The Randolph Hotel capitalised on the Morse factor and named their bar the Morse Bar. As a member of the Oxford CID, I used to visit this bar which was a regular haunt of officers each month before a long weekend. We would say: 'It's time for a Morse moment' and we would enjoy the drink together.

Officers also attended public houses used by Morse in the series such as 'The Trout' at Godstow, 'The White Horse' in Broad Street, 'The Turf Tavern' in Bath Place, 'The King's Arms' in Holywell Street, and 'The Victoria Arms' in Marston.

The regular appearance of Morse and Lewis in public houses is accurate. In the 1970s and 1980s, detectives were expected to attend public houses to seek knowledge from informants and to observe those involved in active crime. Officers would receive reimbursement for any drinks consumed if there was a legitimate reason for attending the particular premises.

If, as a CID officer, you had a reported crime associated with one of the colleges of Oxford University you would comment in a humorous way to colleagues that you had a 'Morse job'. During the period depicted by the series, the actual reports of crime in Oxford colleges or the University as a whole came second place to that reported from the social housing estates of Oxford and general crime within the city's shopping and business centres.

## Musical Morse

Morse had an effect upon the listening habits of Oxford's police officers! The haunting music of the TV series stimulated an interest in classical music, and I know many officers who would play the theme tune in their cars going to and from work. In the station itself you would often hear radios in offices playing a selection of classical music. Morse was the exemplar.

## Do I Recognise Morse as an Oxford Detective?

I am asked many times how accurate the Inspector Morse series is. My answer is that it is not. It does not match, for example, other British television series like *The Sweeney* or *The Bill* which, in my opinion, are far more accurate in respect of police procedures and organisational details. John Thaw starred in *The Sweeney* and his character as Morse is completely different. An example of fiction being stranger than truth – a detective inspector or detective chief inspector would not actually make enquires, obtain witness statements or interview suspects. They would direct operations, advise on policy and, at the end of the inquiry, supervise the necessary prosecution file for the courts. They would, however, attend the scenes of serious crime such as murder. The workhorses were and are the detective sergeants and constables. D. S. Lewis, in *Morse*, it could be said, is a prime example of a hard-working sergeant.

## Dexter and Police Procedure

In later years on meeting Colin Dexter, he said that when writing the books he had no idea as to how the police force was organised, how they investigated crime and the 'politics' involved. His novels are wonderfully entertaining and remain so to this day. Colin Dexter became a popular celebrity throughout the country; meanwhile back in Oxford, he would be regularly seen in the city and standing outside his home in North Oxford conversing.

I recall towards the later years of my service taking part in a weekly BBC Radio Oxford programme with Colin Dexter in which listeners were asked to investigate the fictional murder of a Marylyn Spence at an Oxford College. Listeners would be given certain clues and they would have to investigate and then suggest who carried out the deed. Colin and I would direct the narrative processes of such investigations.

Colin Dexter's books and the *Morse* television series continue to be very popular nearly four decades on. It has all the right ingredients: setting the stories in Oxford with its majestic architecture and using the colleges as the crime scenes for most of the plots – but mostly creating the character of Morse. That was, indeed, a master stroke. Along with Lewis, he investigated many murders and it must be said had a successful detection rate. Yet, strangely, as the series continues, Oxford appears the murder capital not only of the UK but of Europe, too!

### Endeavour Unwrapped

Latterly, *Endeavour* has appeared on screen since April 2013. This series takes us back to the early years of *Morse*, the late 1960s, and up until the mid-1980s. I joined the Thames Valley Police in 1973 and can say that the script writers reflect fairly accurately the organisation, characters and social issues of the era. I worked with detective chief inspectors very similar to the character of Detective Inspector Fred Thursday, Endeavour's mentor and friend. I also served alongside several superintendents whose characters were very similar to that of Chief Superintendent Reginald Bright. It is a shame that more of the scenes in *Endeavour* were not filmed in Oxford, particularly the 'Cowley Police Station'. The real Cowley Police Station was built in the mid-1960s and is in the style of a modern office block situated close to the then-industrial heartland of Oxford. It needed a bigger part.

### Dexter, Morse and the Oxford Legacy

So Colin Dexter, his creation of Chief Inspector Morse and his investigation of murders in Oxford City created a genre still popular today. Many come to Oxford and visit the places they have seen on television or have read about in the books. They enjoy retracing the steps of Morse and Lewis and having a pint of beer at the many 'Morse pubs' in the city. Those using the open-topped Oxford Bus Tour for many years would have seen a cardboard cut-out of Morse displayed in a first-floor office of St Aldates Police Station with a notice saying

'Morse's Office'. The police based in Oxford have enjoyed the 'Morse effect' and added some humour.

Colin Dexter is a fine crime writer astute enough to base his characters in the beautiful city of Oxford – and investigating a seemingly endless series of murders within the academic world of the Oxford colleges. Dexter and his creation Morse will long remain in people's hearts.

## Note on the Contributor

Dermot Norridge is a former Thames Valley police detective, having served for 31 years, twenty of them as CID in Oxford City. Upon retiring, he started a private investigation business based in Witney which is still very active today. Colin Dexter became a patron of ABI – the Association of British Investigators of which he is a member.

# SECTION 4
## The Early v. the Late Morse

# Introduction

John Mair

The *Morse* series is simply back to front. First the older (late) Morse as the grizzled, cynical detective who knew it all but remained unhappy in love and in work. John Thaw put his skin into that character. So much so that Colin Dexter dictated in his will that no other actor was ever to play Morse. The red Jaguar (in the books a Lancia but the TV people thought not posh and distinctive enough), the limp, the love of ale and the sheer brainpower made the Morse character.

Late Morse came to an end in 2000 with 'The Remorseful Day' when he suffers a heart attack in the quad of Exeter College. Fans still queue to sit on the Morse death bench. Thaw retired and died the next year.

But his faithful steer Sergeant, later Inspector, Robbie Lewis lived on for another 33 films from 2006. He had his own sidekick in Hathaway. But Lewis, too, came to an end in 2015 after 33 episodes.

Then the scriptwriters, mainly Russell Lewis, had the brilliant idea of creating a prequel series with the young Endeavour Morse. That, too, has now run for 33 episodes to 2021. Endeavour (the name comes from a crossword clue) was a moniker which Morse did not reveal until late in the original series. He is Morse in chrysalis. Thoughtful, maybe too much so; clever, maybe too much so as befits a man with an MA (Oxon) failed, learning the trade in and out of uniform and avoiding (mostly) the slings and arrows of the politics of the police. Endeavour Morse shows his detective powers even when confined to Thames Valley Police Siberia in the police station in Woodstock and the basement of the CID in Oxford. He shines out from his contemporaries and forms a bond with his boss Fred Thursday and a putative bond with his daughter Joan. As ever with Morse, unrequited.

The academic field of Morse Studies is not very large. Plainly it is too ingrained in popular culture to merit study. In this section, two of the few Morse scholars, Dr Richard Hewett, of the University of Salford, and Professor Jen Webb, of the University of Canberra, place the young Morse against the old and choose between them.

Chapter 10

# Inspecting the Story-Lines of *Morse* and *Endeavour*

Richard Hewett explores the plots of the two celebrated
detective series and argues that those in *Endeavour*
'make it better suited to the 21st century
television viewing environment'.

*Inspector Morse* (ITV, 1987-2000) was ground-breaking television
drama. Tapping into the heritage aesthetic established a few years
earlier by *Brideshead Revisited* (ITV, 1981), it reproduced many of the
detective genre traits already present in the Colin Dexter novels from
which the series was (initially) adapted, while repurposing them into
something completely new for the UK television screens.

Chief Inspector Morse (John Thaw) was a curmudgeonly yet brilliantly
cerebral leading character, possessing various distinguishing character
quirks of the type viewers had come to expect from their television
detectives; in this case, a love of classical music, *The Times* crossword
and real ale. A misfit at work, Morse's personal life was not so much
complicated as non-existent. If he exhibited any form of attraction
towards a female, she would inevitably be revealed as either the victim,
the killer or undeserving of his emotional investment.

In time-honoured fashion, Morse's sidekick, Sergeant Lewis (Kevin
Whateley), was trusty but unintellectual (following in the mould of
Watson, Hastings, et al), though he could usually be relied upon to
make a bland yet vital observation that would provide Morse with the
clue required to turn the case around, prompting the latter to exclaim:
'You've done it again, Lewis!' There was also a sardonic pathologist,
Max (Peter Woodthorpe), and an irascible boss, Chief Superintendent
Strange (James Grout), frequently at the end of his tether with his
unconventional subordinate. In addition, Dexter himself made various
Hitchcock-like cameos, invariably staring straight into the camera
whether pretending to be an Oxford don or a pub local.

## *Morse* – Managing to Transcend Genre Norms

If this description makes *Morse* sound like identikit crime drama, it
was anything but. The series managed to transcend genre norms, not
least due to the inspired casting of John Thaw, essaying an entirely

different kind of television detective from *The Sweeney*'s Jack Regan, and his on-screen chemistry with Whateley's Lewis. Combined with the Oxford college locations and a memorable score by the late Barrington Pheloung, *Morse*'s languid pace and elegiac tone set it apart from all that had gone before. There were seldom any fisticuffs, Morse's Jaguar was never involved in a high-speed chase, and the sedate tempo was further facilitated by the fact that each episode lasted not one but two hours. It is easy to forget how innovative this was today, when the 8 to 10 pm slot is typically filled by crime dramas such as *Midsomer Murders* (ITV, 1997- ) and *Vera* (ITV, 2011- ). In this respect, *Morse* represented something new and highly distinctive, and went on to win a slew of awards, including two Best Actor BAFTAs for John Thaw.

By the time the prequel *Endeavour* (ITV, 2012- ) went into production, the UK television landscape had changed almost beyond recognition, and this had a significant impact on the types of narrative featured in the programme. The fragmentation of broadcast audiences, due to an ever-increasing number of channels and streaming platforms, means programme-makers must now work much harder to keep viewers coming back for more, and the days of a detective solving a different crime every week – in episodes that can be watched in any order, with no need for character arcs or narrative through-lines – seem increasingly archaic. As an episodic drama, *Inspector Morse* seldom referred back to previous stories, and viewers were seldom called upon to remember what had happened the week before, let alone two series ago. Even the name of Morse's former paramour – whose rejection of him led to the abandonment of his studies at Oxford – was changed from Wendy in 'The Last Enemy' to Susan in 'Dead on Time' (an error later retconned in *Endeavour*).

Only the final episodes, which took the form of annual 'specials', began to scatter some crumbs of narrative continuity – after much indecision, Lewis finally applied for his inspectorship, and Morse briefly acquired another love interest – but Strange and Morse's resentment over changes taking place in the force, and their talk of retirement, were already present in the later Dexter source novels, rather than representing a decisive effort by the series writers to provide a closing narrative thread.

By contrast, *Endeavour* features a more carefully thought-out narrative arc, courtesy of Russell Lewis, who has scripted every episode to date. In contrast to the various writing talents who worked on *Morse*, Lewis represents what we now understand as the showrunner: an executive

producer responsible for the overall shape of each series (formerly the role of a script editor, working in conjunction with a producer). This means that, while casual viewers can 'drop in' and enjoy the storyline of the week (i.e. the crime being solved), regular audiences are rewarded by seeing the gradual development of character relationships and on-going background storylines.

In 1987, Morse and Lewis were thrown together in the first episode, and the burgeoning friendship and respect that developed between them was largely due to writers picking up on Thaw and Whately's on-screen dynamic, rather than a carefully orchestrated game plan. In *Endeavour*, viewers see the relationship between young Morse (Shaun Evans, who avers that he has never watched any of the Thaw episodes) and Detective Inspector Fred Thursday (Roger Allam) blossom as the latter takes Morse under his wing – but there are several narrative ups and downs along the way. In addition, each series has its own 'arc'. While these are initially straightforward, they become increasingly complex, to the extent that viewers of series six require extensive knowledge of events from series five to fully comprehend what is going on.

## Explaining the Complexities of *Endeavour*'s 'Narrative Arc'

In the pilot episode, Constable Morse returns to Oxford, where he flunked his degree, to join Cowley police station. He meets Thursday and Max (James Bradshaw) for the first time. By the end of the episode he has replaced the corrupt DS Arthur Lott as Thursday's 'bag man' (sidekick). Over series one, Morse forms a friendship with uniform PC Jim Strange (Sean Rigby), but the main thread is the need for Morse to pass his sergeant's exams. He is initially supplanted as Thursday's bag man by the more qualified – but less capable – DS Jakes (Jack Laskey), who is resentful of Morse. The new station boss, Superintendent Bright (Anton Lesser), is also dismissive of Morse's abilities. There is clearly an attraction between Morse and Thursday's daughter, Joan (Sara Vickers), though it is Jakes she illicitly dates. At the end of the series Morse misses his exam after being shot in the line of duty (perhaps accounting for John Thaw's limp when he played the role).

Freemasonry is a recurring theme in the second series, as Strange joins a lodge, and key pieces of evidence begin to go missing from the station. Morse begins dating his neighbour, nurse Monica Hicks (Shvorne Marks), and considers leaving the force to be with her. In the closing episode, Morse and Thursday have a Mexican stand-off with some

corrupt officers, all of whom are Masons (potentially explaining Morse's later resentment of the society in 'Masonic Mysteries'). In a series cliff-hanger of the type that never featured in the original programme, Morse is framed for the murder of a superior officer, while Thursday is shot – perhaps fatally.

In series three, Morse is cleared of charges and returns to duty, along with Thursday, who now has a bullet lodged in his chest. Although Morse's relationship with Monica has ended, she still appears in some episodes. When Jakes – who has now developed a healthy respect for Morse – departs, the recently promoted Strange takes his place, overtaking Morse in rank, while capable WPC Trewlove (Dakota Blue Richards) also joins the team. Morse finally sits his sergeant's exams. In the series finale, Thursday coughs his bullet up, and the bank where Joan works is subject to a heist. She and Morse emerge alive, but the trauma proves too much for her, and she leaves Oxford.

## How the Plots Twist and Turn

In series four, Morse's exams papers have gone 'missing', and his promotion is again delayed, despite Bright (who is now a supporter of the young detective) intervening on his behalf. Although murders are still solved, and the closing episode sees both Thursday and Morse promoted for their work, the focus is on Morse's feelings for and attempts to track down Joan, who is now involved with a married man, and later miscarries.

Expanded to six episodes, series five has a preponderance of main threads, namely:

- the arrival of gauche new DC George Fancy (Lewis Peek), who is placed under the reluctant Morse's wing and begins a relationship with Trewlove;
- the impending closure of Cowley station, with the coming of the new Thames Valley headquarters (in a nod to *Morse*, a model of the building from the original series is glimpsed);
- the team's on-going investigation of local gangster Eddie Nero, who seems to be involved in several of the deaths they investigate.
- Thursday's investment of his nest egg in a scheme put forward by his brother Charlie (Phil Daniels).

The shape of the future is represented by brash robbery detective Ronnie Box (Simon Harrison), with whom both Morse and Bright

clash during an investigation. At the end of the series Nero is killed, and Fancy is shot dead in mysterious circumstances. Trewlove leaves the team to join the Met, and Thursday loses his life's savings. Bright, Thursday, Strange and Morse eye the future with uncertainty.

Series six focuses on the gradual reassembly of the old Cowley team, who have now scattered and dispersed. Morse is back in uniform at the Woodstock station, while Thursday, whose marriage is now in trouble, has been demoted following Fancy's death, and is working for DCI Box. Bright is in charge of Traffic and has become the public face of a pelican crossing campaign for children, while Strange continues to investigate Fancy's death behind the scenes. Over the course of the series Morse returns to plainclothes work at Thursday's side, while Thursday loses his moral compass, accepting a financial 'sweetener' from Box before changing his mind and taking a stand against police corruption with Morse, Bright and Strange in the final episode.

Series seven, the most recent to be broadcast at the time of writing, consists of just three episodes, and is the closest the show has come to being a pure serial, revolving around a string of towpath murders that bring Morse and Thursday into conflict when the former believes the latter has arrested the wrong man. At the same time, Morse is compromised when he begins an affair with the wife of his former classmate, Ludo Talenti (Ryan Gage), a conman who is secretly manipulating Morse to his own ends.

## Conclusion: The Importance of the Strong Narrative

Little narrative development of this complexity was ever seen in *Inspector Morse*. All audiences needed to know was that Morse and Lewis were two detectives in Thames Valley CID; one was grumpy and clever, the other wasn't, and crimes were neatly solved within the space of a single episode, leaving the protagonists free to work on a fresh case the following week. Viewing habits of the day required little more, and in this pre-catch-up era *Morse* reached what now seem like unattainable viewing figures of 18 million.

*Endeavour*'s on-going story elements arguably make it better suited to the 21$^{st}$ century television viewing environment, the more serialised narratives of series four and seven offering a strong narrative hook to viewers now likely to be tempted away by Netflix, Amazon Prime and various iPlayers. *Inspector Morse* and *Endeavour* were made in different times, for different audiences, and if the former were launched on television today it would doubtless take Dexter's source material in

radical new directions. However, the fact that, thirty-five years after he first appeared on British screens, *Morse* remains a such a vivid presence is a testament to the impact of the original series, and its ability to rise above the tried and tested norms of television detective drama.

*This chapter is an updated and reworked version of a blog originally published by CST online as 'Endeavouring to Investigate Narrative Developments in Morse', available at https://cstonline.net/endeavouring-to-investigate-narrative-developments-in-morse-by-richard-hewett/.*

## Note on the Contributor

Dr Richard Hewett is Senior Lecturer in Contextual Studies for Film and Television at the University of the Arts London. He specialises in screen performance and television adaptations, and has contributed articles to *The Journal of British Cinema and Television*, *The Historical Journal of Film, Radio and Television*, *Critical Studies in Television*, *Adaptation*, *Series – International Journal of TV Serial Narratives* and *Comedy Studies*. His first monograph, *The Changing Spaces of Television Acting: From Studio Realism to Location Realism in BBC Television Drama*, was published by Manchester University Press in 2017.

# Chapter 11

# Why I prefer *Endeavour* to *Morse*

**Is the young Morse, as seen in *Endeavour*, a better person than the old cynic he becomes in *Morse*? Jen Webb, of the University of Canberra, comes down firmly in favour of the former.**

Detective fiction is my go-to when I need to wash away the exigencies of everyday life. I'm not alone. Sales and TV viewing figures show the enormous popularity of the form; its benefits have been observed for mental health and well-being, and it provides theorists with the pleasure of analysing social structures, identity and political imperatives through its lens. My favourite detective is Endeavour, though I admit that I don't like Morse, a creation of the novelist Colin Dexter, which was voted the greatest British crime drama of all time.

I like Morse's car, his taste in music, his capacity to disentangle mysteries as perplexing as Gordian knots. But I don't like his old-man grouchiness and his dated gender politics. This frees me to take real pleasure in the prequel centred on his younger self, Endeavour Morse (played by Shaun Evans), untrammelled by any need to relate Baby Morse to the curmudgeon he would later become. Endeavour, or to quote critic Graeme Virtue, 'Inspector Morse with a moustache', has been attracting fans since the show's 2012 inception. (The moustache has come and gone over seven seasons screened so far, but Endeavour's quirky, difficult self continues to grab my attention.)

## Endeavour: The Hidden Genius?

An Oxford University dropout, Endeavour is brilliant, canny and willing to do whatever is necessary to achieve the public good. In this he is a closer match to the Ancient Greek king Odysseus, as depicted by philosopher Martha Nussbaum (1976), than to television versions of Agatha Christie's Hercule Poirot or G. K. Chesterton's Father Brown. And like Odysseus, he seems always to be searching for a home. Endeavour is unimpeachable, displaying a touch of arrogance that frequently offends others, especially Chief Superintendent Bright (Anton Lesser) who regularly slaps him down. His self-belief similarly puts off the dons and upper-crust toffs he encounters in his investigations.

The story begins in the early 1960s, in a Britain still recovering from war, and it progresses, season by season, to 1970. It is beautifully filmed, providing all the visual nostalgia one could hope for: heavy-flanked cars, aggressively loud wallpaper, dim and grim interiors. Outside, there is the glowing presence of the dreaming spires that signal 'Oxford' to the viewer. Endeavour moves with aplomb through disturbing situations that tend to draw together unlikely elements of Oxford society. Fey schoolgirls drift about in white gowns like some cold-climate transplants from *Picnic at Hanging Rock*. Public schoolboy bullies and drug-runners abound. Academics go rogue. London gangsters in Kray Brothers suits show murderous intent and rough manners. There's a piling up of bodies, week by week, that is worthy of *Midsomer Murders*, all underscored by haunting music created by the prolific Australian composer Barrington Pheloung, who was said to sneak clues and red herrings into his compositions.

## Keeping Good (Copper) Company

A real delight is found in the community Endeavour inhabits. Alongside Chief Superintendent Bright is the lugubrious Detective Inspector Fred Thursday (Roger Allam), who doubles as Endeavour's surrogate father.

Colleagues include DC Jim Strange (Sean Rigby) – less capable than Endeavour, but much better at the institutional game. There is also the rather unfocused and short-lived DC George Fancy (Lewis Peek) and George's girlfriend, WPC Shirley Trewlove (Dakota Blue Richards), who matches Endeavour in insights, observation and clarity of thought, before heading off to greener pastures after her Fancy is killed in action. (Note the cryptic poetry of the officers' names, which seem to be crying out for a code-breaker – and note too: Endeavour was a cipher clerk before joining the police.)

Outside the station community we get to know Thursday's wife, Winifred (Caroline O'Neill), and their daughter, Joan (Sara Vickers), for whom Endeavour hopelessly yearns. Both women are independently-minded and their stories help shape the narrative arc of the series. There's the nurse Monica Hicks (Shvorne Marks), Endeavour's neighbour and, for a time, his girlfriend. She is tender and generous, but finally intolerant of his failings in romance. There's also the courageous, ethical editor of the *Oxford Mail*, Dorothea Frazil (Abigail Thaw, daughter of *Morse* star John Thaw).

## Benefits of an Oxford Education?

Endeavour wears his Oxford education lightly but draws on its foundation to solve the crimes; his fellow officers routinely turn to Endeavour to find answers to the really complex cases – particularly those that depend on opera, or archaic poetry or codes. Consistently he fulfils what philosopher Slavoj Žižek (1991) calls 'the detective's role' – to demonstrate how the impossible is possible. He sees the order in apparently random events; demonstrates how a distraught woman had, in fact, arranged the murder-at-a-distance of her husband; recognises where the killer is likely to make his next appearance; stitches together hints and glimpses so he can deliver the checkmate move in whatever case he is pursuing. What seems impossible, or magical, becomes lucid under his analytical gaze.

## Endeavour v. Morse

Finally, Endeavour reminds me how difficult it was to be young. To know you don't fit in any of the places where you need to be. To have conviction in some aspects of life and be so uncertain in others. Endeavour must accommodate triumphs that deliver not restoration to order or, in the words of fellow Oxford man and poet W. H. Auden (1962 [1948]), 'the state of grace in which the aesthetic and the ethical are as one'. Rather, his successes give way to an exhausted and saddening awareness of how damaged everyday people are, stumbling through our everyday lives.

*This piece first appeared in the Conversation (Australia), in December 2020. It is reproduced with permission of the author.*

## References

Nussbaum, Martha (1976) Consequences and character in Sophocles' Philoctetes, *Philosophy and Literature*, Vol. 1, No. 1 pp 25-53

Žižek, Slavoj (1991) *Looking Awry: An Introduction to Jacques Lacan through Popular Culture*, Cambridge: MIT

Auden, W. H. (1962 [1948]) The guilty vicarage: Notes on the detective story, by an addict, *The Dyer's Hand and Other Essays*, New York: Random pp 146-158

## Note on the Contributor

Jen Webb is Distinguished Professor of Creative Practice and Dean of Graduate Research at the University of Canberra. Recent publications include *Art and Human Rights: Contemporary Asian Contexts* (Manchester UP, 2016), the edited volume *Publishing and Culture* (with D. Baker and D. L. Brien, CSP, 2019), and the poetry collections *Moving Targets* (Recent Work Press, 2018) and *Flight Mode* (with S. Hawke, Recent Work Press, 2020). She is co-editor (with Paul Hetherington) of the literary journal *Meniscus* and the scholarly journal *Axon: Creative Explorations*.

# SECTION 5
## Oxford and Morse

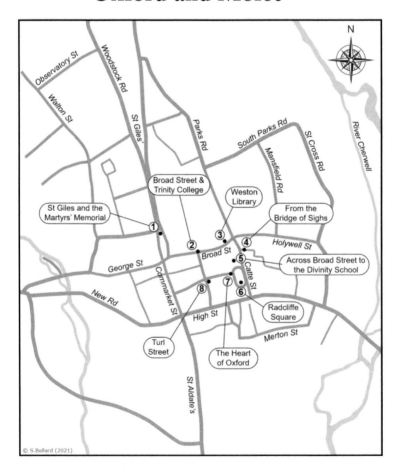

© S.Ballard (2021)

# Introduction

John Mair

What of his home patch? Oxford made Morse and Morse made Oxford. He loved Oxford but has it been reciprocated?

The television series firmly branded the town as 'Morseland'. The City's image used to be of the dreaming spires, college quadrangles and petty politics to the full. Oxford, the university, had been on the map for nearly one thousand years. It is now the best in the world and not just for vaccines.

The *Inspector Morse* TV series moved the city kicking and screaming into the 21st century. It brought, or should have brought, a vibrant tourist industry as well. Has Oxford looked after the *Morse* franchise well enough? Has it exploited it to the full? In my view, not. The figures tell a story of (pre-pandemic) opportunities missed. When (and if) domestic and international tourism comes back to Oxford, is it time to grasp the nettle and create a 'Morse Trail' – a series of *Morse Codes*. Make it clever like the man.

Some have mapped Morse as Cara Hunter did earlier with DI Fawley. Here, Dr James Cateridge, of Oxford Brookes University, presents his map.

Finally, THE *Morse* super fan, Christopher Sullivan, takes us into the *Morse* Universe. Strange but interesting.

# Chapter 12

# The Strange Case of the Disappearing Morse Franchise in the City of Spires

Has Colin Dexter left a Morse legacy in Oxford? Rarely has one author and his creations dominated a city as much as Dexter, Morse and the case of Oxford. But does Morse's 'home town' appreciate and develop Morse? John Mair investigates from Jericho – and argues for a *Morse Code.*

Naturally curious, I decided to don my best investigative skills and explore *Morse, Lewis* and *Endeavour* and the Oxford they inhabited and have left behind. But you need to be a real detective to find the trace – just two blue plaques in the city at St Aldates Police station and the railway station. Beyond that it's down to the knowledge of the guides who ply their trade in the city and books like these. Not much reward for a TV series watched by more than a billion people worldwide and which has provided Oxford with hundreds of hours of prime-time advertising.

## Finding the Morse Effect

Try to find the Morse effect on Oxford tourism – a simple question you would think with a not complex answer. First stop those charged with counting numbers – the City Council and Experience Oxfordshire, the county's tourist body. To be frank, their data bank was empty with figures only up to 2014 – seven years ago! Then, to Oxford Brookes, one of the two city universities and their tourism management faculty. No joy. Likewise, at the economic think-tanks in the City – Oxford Economics and LMC. Nor at Creative England, an oxymoron if there ever was one, in any of their work on cultural tourism. It felt like the trail was running cold and it was time to give up. Not this Morse clone.

But then, as in all the best Morse stories, a one-line break-through. At a birthday party (my own) in an Oxford pub, Councillor James Fry said five words: 'Strategy Review on Tourism 2019'. I found it. Dry but very useful.

That report was the result of a group of mandated councillors asking pertinent questions about the Oxford tourism product and what could to be done to improve it.

## It's the Data, Stupid!

It is not a detective nose nor intuition but data that provided the answers.

In 2017, there were one fifth the number of overnight compared to day-tripper visitors to Oxford (1.2m. compared to 6.4m.) yet they spent almost 50 per cent more in total (£406m. compared to £277m.). Overseas overnight visitors – up by 25 per cent in five years – stayed longer (6.1 nights compared to 2.3 nights) and, as a result, spent more money on accommodation, shopping and so on. One in eight jobs in the city was supported by the tourism economy.

By 2019, overseas visitor numbers were being outpaced by day-trippers coming on coach tours from London to the Cotswolds, Stratford and Bath. On and off the coach for four hours. It is difficult to take in much of a city and spend much money if you are only there briefly and passing through.

In any case, coaches were seen as a problem and nuisance rather than the bringers of customers. They were parked in inconvenient places and, in some cases such as outside the Ashmolean Museum, actively discouraged. The 2019 Strategy Review Group was not entirely positive in its conclusions:

'The data shows that people are less likely to return to Oxford than most other city destinations, and their satisfaction is significantly lower on average than experienced elsewhere in the UK (39 per cent compared to 48 per cent). The results suggest that Oxford may become increasingly uncompetitive in the regional market, if efforts are not made to improve the visitor experience, which may have knock-on effects for the visitor economy in the medium term.'

## Covid Trumps Strategy

The detailed action plan the group suggested went up in flames within a year. From March 2020, the Covid pandemic came with a national/international lockdown (through with breaks to July 2021) and tourist numbers simply fell through the floor. Oxford tourism – both domestic or international – was now a thing of the past.

In a follow-up Strategy Review report in September 2021, the city council noted that by October 2020 tourist numbers had dropped 52 per cent year on year. This update suggested that it was expected the economy would take at least three years to recover lost ground with a span of four to seven years to full recovery of demand for the global tourism economy. So Oxford tourism would not be back to the good old days until 2025.

The tourism information system was poor in 2019. The one office had been moved from the main bus station – close to the public toilets – to the centre of the city in Broad Street. But then after that 2019 report, the city took the decision to pull the plug on the Experience Oxfordshire subsidy and the tourist office it financed there and that has closed. Tourists are left with the internet, established publications and a cacophony of tour guides. Self-guiding is not easy either. Signage within the city centre is poor. You need strong glasses to read the illuminated signs that pop up all over.

Would any other city with a strong literary heritage blow it as Oxford has apparently done with Morse? Imagine Stratford upon Avon without Shakespeare, Broadstairs without Charles Dickens or Bath without Jane Austen. In a recent UK Cultural Cities survey, Oxford came a mere fourth. No mention of Dexter and Morse in that but plenty of J. R. R. (*Lord of the Rings*) Tolkien and the Inklings. Put simply, Oxford hides the Morse legacy under a rather large bushel.

## What is to be Done?

When domestic and international tourism returns to Oxford nest year or later and even before that it is time for radical action. *Morse, Lewis* and *Endeavour* may be the fictional creations of Colin Dexter and others but they are firmly fixed in the consciousness of millions of TV viewers and readers of the books. It is a franchise of the mind. That needs to be fed and served.

To this amateur detective and micro economist, the solution seems simple. Create a Morse Trail of eight to ten stops rather like the one outlined in this this book. Not blue plaques but *Morse Codes*. Mark them out, develop literature and tours based on that trail. Declare that Oxford is proud, after all, of Morse, Lewis, Hathaway, Thursday and others.

Case solved?

## Note on the Contributor

John Mair has lived in and around Oxford for thirty years. For the last five, he has been a resident of Jericho in the city centre. He is the generator, curator and overall editor of this guidebook and the editor of 41 other 'hackademic' texts over the last twelve years.

# Chapter 13

# Mapping Morse

Inspector Morse fans who visit Oxford to follow in the footsteps
of their detective hero demonstrate an imaginative overlapping
between place and character which can also be illustrated
by user-generated online maps and photo-sharing services.
James Cateridge searches for clues in the geography.

## A City for Detectives

In a pandemic era when tourist activity has suddenly halted, residents
and businesses based in tourist hotspots such as Oxford are in a unique
position to reflect upon what tourism has brought to their cities and
what it might bring in the future. With an eye to recovering valuable
income, policymakers and destination managers must go back to basics
to establish what makes their tourism offer special. So why do people
want to come to Oxford? The most obvious answer to this question is
the city's visual appeal: the 'dreaming spires' described by Victorian
poet Matthew Arnold and featured on countless postcards,

photographs and social media posts. But Arnold's oft-quoted line is not just a visual description, it is also an imaginative one. It implies that the value of the architecture in a place like Oxford is what it has inspired in the minds of its visitors, be they artists, students, or even humble day-trippers. According to contemporary author Philip Pullman, Oxford is a place where, "The real and the unreal jostle in the streets... where windows open into other worlds" (Pullman 2003: i). Both Arnold and Pullman's visions of Oxford are of a place which is made not just of beautiful buildings, but also of stories: dreams, works of literature, and films and television shows. These stories are vital for attracting tourism because they offer a lively vision of a place packed with incident and drama, as well as powerful emotional connections with characters whose personalities have become synonymous with the spires themselves. Over the last half a century, the character who has come to stand for the city most successfully is the fictional detective Inspector Morse.

The *Inspector Morse* franchise, made up of Colin Dexter's novels written between 1975 and 1999 and the TV drama series *Inspector Morse* (1987-2000), *Lewis* (2006-2015) and *Endeavour* (2012-) has been a potent and consistent driver of tourism to Oxford for many reasons. Firstly, the international success of the TV series mean that Morse is a character known to audiences all over the world. At its peak, the show's global audience was estimated to be around 1bn viewers in over 200 countries. Secondly, just as important as the series' international reach is its strong local flavour. The show makes extensive use of locations in and around Oxford, and this is an important element of its high production values. The original *Inspector Morse*'s convoluted murder mystery plotlines typically rely upon the city's eccentricities, such as 'The Wolvercote Tongue' (first transmitted on Christmas Day in 1988) which builds Oxford tourism into its plotline, as suspicion falls upon tourists, tour guides and employees of the Ashmolean Museum. However, perhaps the most important explanation for *Morse*'s appeal to tourist fans is that, like many detective narratives, *Morse*'s plotlines are about investigating both people *and* places. Detectives are typically characters with agency in a very real physical sense. They have the freedom to move around their local area with impunity, to find clues, to locate and follow suspects, and finally to apprehend the guilty parties. This vital spatial element of detective narratives mean that fans can literally follow in the footsteps of their beloved heroes or heroines, looking for their own signs or clues, such as locations used within their favourite show. This process can

form intense relationships between story and place, through the detective who is inseparable from the place he or she investigates. By exploring the visited location in detail, sometimes going back over the same spots many times, tourist fans can find signs which accumulate into a kind of cartography of character: personality as action which takes place on a map.

Oxford's tourist brand relies heavily upon the University, both in terms of its intellectual reputation and its striking architecture and green spaces. However, as visitors to Oxford quickly discover, the University-owned land which dominates the city centre is often inaccessible. Whilst walking around the city, college life with its dorms, dining halls and quads can only be glimpsed through locked gates carrying signs that unambiguously state 'Closed to Tourists'. This is a rude reminder that Oxford's intellectualism functions as an exclusive club, wonderful and empowering for those inside but opaque and impenetrable to those who are not. In a similar vein, Morse also has an interestingly ambivalent relationship with the University. Whist he was an Oxford undergraduate, Morse failed his degree in mysterious circumstances, making him half insider and half outsider in relation to the city's privileged elite. Behind closed college doors, secrets lurk, and secrets lead to corruption. The show's plotlines famously depict this powerful elite as corrupt in murderous ways. For example, in the first episode of series two of *Lewis*, 'And the Moonbeams Kissed the Sea' (first broadcast in February 2008), two apparently unrelated victims, an undergraduate art student and a custodian at the Bodleian Library, are both killed by an English professor because of their involvement in a scheme to sell forged manuscripts. Morse's physical access behind the closed doors of the University may be challenging for tourist fans to fully recreate, but the snobbery and social barriers which he also encounters are surely easier points of identification for visitors to Oxford.

## Beyond the Case

Like the hard-boiled detectives of Hollywood crime cinema, Morse is placed somewhat outside of mainstream society. He struggles to maintain romantic relationships and becomes involved with alluring, but deadly, *femme fatales*. The hard-boiled genre is a clear influence upon Colin Dexter's creation of Inspector Morse, whose international appeal surely rests upon the translation of these familiar clichés into a very different genteel English setting. Hard-boiled detectives are also usually alcoholics, and this stereotype at least is easy to translate: from

smoky bars serving neat bourbon to oak-beamed pubs and pints of bitter for lunch. Morse's penchant for Oxford pubs is a gift to those canny operators who offer Morse-inspired walking tours around the city, always calling at well-known Oxford haunts such as 'the Turf Tavern.' The Turf Tavern used to be famously difficult to find, but in the era of *Google Maps* and ubiquitous smartphones this 'hidden gem' appeal is somewhat diminished.

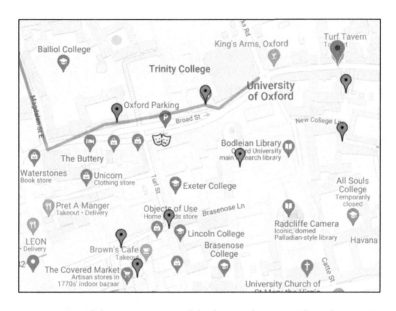

*Figure 1. Detail from a user-modified Google Map of 'Colin Dexter's Inspector Morse'. ©2021 Google.*

Figure 1 shows an example of a user-modified *Google Map* of Morse's Oxford including places described in Colin Dexter's original novels, shooting locations from the television series and even walking routes (and pub crawls) which can enable Morse fans to explore the city just as their hero does. When used with a smartphone these maps are capable of displaying the tourist's real location within Morse's fictional world, further blurring the boundaries between place, story and character*

It is also important to remember that the Morse franchise is not just an archive of old material to be repurposed by fans as *Google Maps*. As *Endeavour*, it remains a hit TV show and glossy period drama which

continues to be shot on location around the city. For tourist fans who are lucky enough to stumble across the show being shot, often it is another key element of Morse iconography which is spotted first: the classic cars driven by the detective throughout his career. Evidence of such encounters between Morse fans and location shooting for *Endeavour* are rife across social media, but they take on a particularly interesting visual form on *Flickr*, a photo sharing service used by keen amateur and semi-professional photographers. Because most images taken with modern devices are 'geo-tagged' (i.e. marked with geographical data indicating where there were taken), *Flickr* can present the publicly-shared photographs in the form of a searchable map. Each of the pink dots on the map can be selected to display a preview of the image, which when clicked is opened in higher definition and with comments by users and fans.

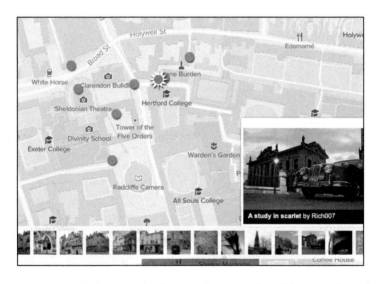

*Figure 2. Flickr's Oxford map of images found by searching for "Inspector Morse". © 2021 DigitalGlobe.*

Figure 2 demonstrates the results of a search for the keywords 'Inspector Morse' as displayed on a geo-tagged map of Oxford. In this example the possibilities of the internet to enable the imaginative maps required by the television tourist is clear. This map captures images which were inspired by stories; written as novels, adapted onto television screens and then played and replayed around the world. The

images it relays are in themselves tiny stories of tourists' experiences and fans engagement with fictional heroes.

## Conclusion

All maps are an argument about space, and all maps have a purpose. Most obviously, maps help us to navigate unfamiliar terrain and avoid getting lost. They lead us to places which we want to see and help us find places which fulfil our basic needs. They may also demarcate territories and reinforce political power. But as historian of cartography Jerry Brotton argues, maps also fulfil a deeper imaginative function, as they are 'always images of elsewhere, imaginatively transporting their viewers to faraway, unknown places' (Brotton 2021: 15). Considering the map as an instrument of fantasy brings us back to the particular focus of this chapter: tourists to Oxford who are motivated to travel by their powerful identification with fictional characters such as Inspector Morse. When the must-see object is less a building or place than a fictional character that inhabits it, a traditional map is just not fit for purpose. What is required is a deeper engagement between place and narrative, a space where stories are just as important as history, and where history has many of the best stories. Oxford, as imagined by Morse fans and then mapped in creative ways through the possibilities of user-modified media and social sharing, is such a place. May its tourists return happily and healthily very soon.

## References

Brotton, Jerry (2012) *A History of the World in Twelve Maps*, London: Allen Lane

Pullman, Phillip (2003) *Lyra's Oxford*, London: Corgi Books

## About the contributor:

Dr James Cateridge is a Senior Lecturer in Film at Oxford Brookes University. His research on media policy, cultural institutions and screen tourism has been published in peer-reviewed journals including *The Journal of British Cinema and Television, The International Journal of Cultural Policy,* and *Humanities.* He is the author (as James Caterer) of *The People's Pictures: National Lottery Funding and British Cinema* (2011) and of *Film Studies for Dummies* (2015).

# Chapter 14

# Confessions of a Super-Fan in the Morse Universe

**Chris Sullivan is a *Morse* super-fan and hosts the popular morseandlewisandendeavour.com website. He traces his infatuation from a dusty bookshop in Glasgow's West End to a full-blown love affair over the near 100 films of the three series.**

I collectively refer to Colin Dexter's novels and the three TV series, *Morse*, *Lewis* and *Endeavour*, as the *Morse* Universe. Colin's first Inspector Morse novel, *Last Bus to Woodstock*, was the Big Bang that created the *Morse* Universe and all its constituent parts. That first novel created a galaxy full of stars, planetary wonders in the shape of Oxford, and the sun that everything revolves around – Colin Dexter.

## Entering the Universe

I came some four years late to Colin's novels in 1980. I found *Last Bus to Woodstock* in a second-hand bookshop on Glasgow's Byers Road. Beyond Sherlock Holmes I had read very few crime novels and to this day I can't be certain why I picked up the novel. It may have been the striking cover of blonde hair framing the low-cut white blouse of a woman whose face is hidden. It was only one of two books in the crime section whose cover was facing out into the shop while all the others were in their normal position of standing like soldiers on parade with their spines marked with only their name, rank and serial number as to who they were. I can't remember what the other book was whose cover faced outward for the shop browsers to see.

On the back cover was a photograph of a young Colin holding a book with a rather impish smile lighting his face. I liked the look of him. I opened the book to access the description on the flap of the wrapper. The first three paragraphs outlined the novel's plot but it was the fourth and final paragraph that interested me greatly and what caused me to hand over the grand sum of fifty pence to the chap behind the counter:

This is a whodunnit in the purest classical mould. Perhaps it is not surprising that the man who was for several years the national champion in writing clues for the famous Ximenes Crossword

competitions should show the same masterly control in presenting the clues in a detective novel. Apart from the puzzle itself this first novel has everything – subtle characterisation, the detailed background of Oxford and Woodstock, the memorable first appearance of Morse, humour and suspense.

## Immersion in the Novels – and Then on the Telly

I arrived home and immediately started reading the novel and never stopped reading until I arrived at the final page. I needed to find Dexter's other novels. By 1980, Colin had written four *Inspector Morse* novels, so I had to hunt them down. I spent the following week scouring the multitude of second-hand bookshops that inhabited Glasgow then thinking I had fat chance of finding the three I needed, *Last Seen Wearing, The Silent World of Nicholas Quinn* and *Service of All the Dead* to complete Colin's quartet of books. But I found them. From that moment, I was part of the Morse Universe and to this day I still am and will always be.

The TV series based on Colin Dexter's novels did not arrive for another seven years. On the 6 January 1987, I sat down to watch the first episode, 'The Dead of Jericho' which coincidentally was the book published one year after I had discovered Morse and the first book I had bought of the Morse series when it was first published. I had feelings of trepidation, but it was a gift of promise as I wondered if they could successfully transfer Colin's novel to the small screen.

Having read some months previously that John Thaw and Kevin Whately were involved in the TV series I was pleased the programme producers had employed two such highly gifted actors. I was surprised that John Thaw was playing Morse as in the books Lewis is older than Morse so one would have assumed John would have played the Lewis character. Thankfully, that was not the case.

After watching that first episode over the two-hour timeslot for the show I had a smile on my face that felt like it began at the earlobe on one side of my head to the other. If the programme producers could maintain the quality shown in the first episode, then this was going to be one of my all-time favourite shows: they did.

## Why I Love *Morse* on TV

I doubt my reasons for loving the *Morse* Universe are any different to many other people's reasons: the Oxford location with its dreaming spires, beautiful architecture, college cloisters that evoke a different

time and place and reminds one that the world can be a civilised place. There is the classical music, music to die for, that permeates much of the three TV series and again triumphs in the knowledge that the world can be a civilised, cultured arena even while there is murder afoot.

The classical music is ably conducted and arranged by Barrington Pheloung (who sadly died in 2019) and Matthew Slater who has taken over the conducting reigns in the latest *Endeavour* episodes since Barrington's death. Both artists also produce wonderful incidental music within the shows to complement and run alongside the classical arrangements. Both composers help the audience to engage with the episodes and to help but not intrude in their enjoyment of each episode.

Barrington and Matthew are only two components in the large machine that helps the *Morse* Universe to be the success it is. The original *Morse* series was a perfect storm of actors, producers, cinematographers, guest stars, directors, writers and musical composers: the great and the good. This perfection in television shows is a rare occurrence but in the *Morse* Universe that perfect storm has formed and created three sublime and memorable shows which, with each wave of series' episodes, show no signs of crashing down on that shoreline littered with forgotten and discarded TV series.

## The Treasure Trove of the *Morse* Franchise

The show and books may be primarily about murder, but it is a treasure trove of a world we wish to inhabit if only to walk alongside, Morse, Lewis, Thursday, and Hathaway. We want to watch intently to see how they will solve those many murders. We wish to share a drink with them and get to know them better. They are characters we care about intensely and so much so that many fans of the original series cannot bring themselves to re-watch the final episode, 'The Remorseful Day'. I am one of those people. Of course, it was heart-breaking enough with the death of Inspector Morse but to have John Thaw die a year after the final episode was transmitted made the heartbreak more strongly felt.

## The End of the *Morse* Universe?

With the end of the *Endeavour* series approaching fans are wondering if the *Morse* Universe can create another spin off planetary body that will encircle the Sun that is Colin Dexter alongside those three other planetary giants, *Morse, Lewis* and *Endeavour*. Speculation is rife in the many Morse forums, fan pages and Facebook pages. A Hathaway

series? A series based on a young Fred Thursday as he is demobbed from the army at the end of WW2 and returns to being a beat constable on the streets of London? Dr Max DeBryn as a pathologist in 1970s Britain?

While we are all driven to distraction wondering what the next show in the *Morse* Universe will be, especially through the dead of winter, we can all have absolute conviction in the knowledge that those shiny Digital Versatile Discs will help us to continue to enjoy and take comfort in the promised land that is Endeavour Morse, Lewis, Thursday, Hathaway et al.

## Note on the Contributor

Having worked as an ecological scientist in the late 1990s and early 2000s, Christopher Sullivan retired from that position to care for his mother some 14 years ago. Sadly, his mother died last year after complications from Covid. He is now back at university reading for a Master's in English Literature. Much of his spare time is spent writing for his website morseandlewisandendeavour.com. And he is the author of *The Complete Inspector Lewis.*

# Appendix 1

## Location, Location – Spot the Location

This is by no means a fully comprehensive list of the locations that are used. It is a guideline to give an idea of where some scenes have been shot, these might be very brief scenes and we may have missed some. Some episodes were not even filmed in Oxford such as episodes 13, 14, 15, 16, 20, 23 and 25 of Morse. Lewis's episodes have used Oxford consistently and frequently. Endeavour used more at the start of filming, back in 2012 but seemed to get less frequent as time passed on, and Oxford got busier – certainly in the main 'university areas.' Team Endeavour then choose, it would seem, to film more outside of

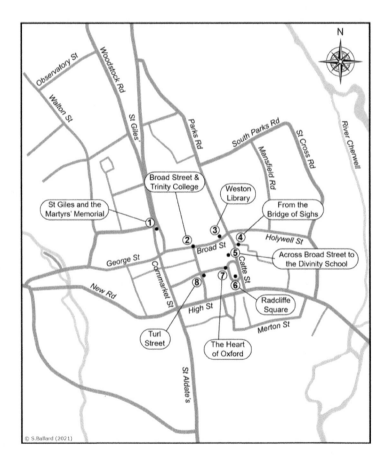

Oxford and using locations such as Beaconsfield or small Oxfordshire villages.

## 1 – Around the Ashmolean

| PLACE | MORSE | LEWIS | ENDEAVOUR |
|---|---|---|---|
| Ashmolean | The Wolvercote Tongue | Whom the Gods would Destroy And The Moonbeams Kiss the sea The Point of Vanishing Wild Justice Fearful Symmetry | |
| Worcester College | The last bus to Woodstock The sins of the fathers Deadly slumber | Fearful Symmetry | |
| St John Street | The Wolvercote tongue | The Lions of Nemea | First Bus to Woodstock, Girl |
| St John's College | The riddle of the 3rd mile | Counter Culture Blues | First Bus to Woodstock Rocket Arcadia |
| The Randolph | The Wolvercote Tongue The Wench is dead The Remorseful Day The Infernal Serpent | Whom the Gods would Destroy Allegory of Love The Quality of Mercy Counter Culture Blues Ramblin' Boy | |
| Martyrs Memorial | The Wolvercote Tongue Deadly Slumber | Reputation Counter Culture Blues | Fugue |
| St Giles | The Wolvercote Tongue | Reputation Old School Ties Fearful Symmetry Down Among The Fearful Entry Woods The Lions of Nemea Beyond Good and Evil | |

| PLACE | MORSE | LEWIS | ENDEAVOUR |
|---|---|---|---|
| Lamb and Flag (Closed) | | | First Bus to Woodstock Arcadia |
| The Eagle and Child | Second Time Round The Way through the woods | Allegory of Love | |
| Pusey Street | | | First Bus to Woodstock, Home |
| Woodstock Road | Last Bus to Woodstock | | |
| Radcliffe Infirmary | The service of all the dead | | |
| Green Templeton College | The Silent world of Nicholas Quinn The Dead of Jericho | | |
| Little Clarendon Street | Death is Now my Neighbour The Wench is dead | Entry Wounds Between Good and Evil | |
| Wellington Square | The wench is dead | | Arcadia, Prey, Harvest |
| Rewley House | Girl? | | |

## 2 – Broad Street, West to East

| PLACE | MORSE | LEWIS | ENDEAVOUR |
|---|---|---|---|
| Broad Street | Twilight of the Gods | | Girl Trove |
| Balliol College | The Day of the devil | The Point of Vanishing | |
| Trinity College | The Last Enemy The Wench is Dead Twilight of the Gods | Music to Die for The Point of Vanishing Falling Darkness Gift of Promise Rambli' Boy Beyond Good and Evil One for Sorrow | Fugue Girl Trove |
| Turl Street | Deadly Slumber The Last Enemy | | Rocket Trove Neverland, |

| PLACE | MORSE | LEWIS | ENDEAVOUR |
|---|---|---|---|
| | The Way Through the Woods | | Coda<br>Game<br>Harvest<br>Deguello<br>Icarus |
| Exeter College | Plenty<br>The Remorseful Day | Life Born of Fire<br>Expiation<br>The Quality of Mercy<br>The Soul of Genius | Home<br>Noctuirne<br>Coda<br>Ride<br>Fugue<br>Arcadia<br>Muse<br>Harvest.<br>Striker |
| Ship Street | The infernal Serpent<br>Greeks Bearing Gifts | The Point of Vanishing<br>Falling Darkness<br>Generation of Vipers<br>Fearful Symmetry<br>Down Among the Fearful | Harvest<br>Colours<br>Quarter |
| The White Horse | The dead of Jericho<br>The Wolvercote Tongue<br>The secret of Bay 5b | Allegory of Love<br>Counter Culture Blues<br>Old Happy Far of Things<br>Rambli' Boy<br>Beyond Good and Evil<br>What Lies Tangled | Girl |
| Blackwells bookshop | Who Killed Harry Field?<br>The Service of all the Dead | Allegory of Love (outside) | |
| Bodelian Library | Settling of The Sun (OSQ) | Whom the Gods would Destroy<br>And the Moonbeams kiss the sea | Fugue,<br>Arcadia,<br>Coda<br>Game<br>Lazareto |
| Museum of the History of Science | | The Gift of Promise | Fugue |
| The Kings Arms | Deadly Slumber<br>The Secret of Bay 5b<br>The Dead of Jericho | Allegory of Love | Home |

| PLACE | MORSE | LEWIS | ENDEAVOUR |
|---|---|---|---|
| Hertford Bridge of sighs | The Dead of Jericho The Last Bus to Woodstock Death is Now my Neighbour | Reputation The Dead of Winter Wild Justice The Mind has Mountains Generation of Vipers The Lions of Nemea Beyond Good and Evil What Lies Tangled | First Bus to Woodstock, Trove, Arcadia, Apollo Deguella Oracle Raga, Cartouche |
| New College Lane St Helen's Lane | | | First Bus to Woodstock Trove, Arcadia Raga |
| The Turf Tavern Helen's passage | The Service of All the Dead The Settling of the Sun | And The Moonbeams Kiss the Sea Beyond Good and Evil | First Bus to Woodstock |
| Lincoln College | | Life Born of Fire Dark Matter Your Sudden Death Question | |
| Mansfield Road | The Dead of Jericho | Allegory of Love Beyond Good and Evil | |
| Holywell Street | | The Point of Vanishing, The Dead of Winter The Gift of Promise, Generation of Vipers, Down Among The Fearful Beyond Good and Evil | Girl Home Neverland Ride Arcadia, Coda Game Lazaretto Deguello |
| Holywell Music Room | The Twilight of the Gods Who Killed Harry Field? | Music to Die For | Colours |
| The Kings Arms | Deadly Slumber | | |

| PLACE | MORSE | LEWIS | ENDEAVOUR |
|---|---|---|---|
| | The Secret of Bay 5b | | |
| Wadham College | Who Killed Harry Field?<br>The Daughters of Cain<br>The Wench is Dead | Reputation | |
| New College | | Whom the Gods Would Destroy | Sway<br>Canticle |
| Natural History and Pitts Rivers museums | The Daughters of Cain | Whom the Gods Would Destroy<br>Wild Justice<br>Beyond Good and Evil | Nocturn<br>Cartouche` |
| Keble College | | | Home<br>Apollo |
| University Parks | | | Prey |

# 3 – High Street West, Carfax, Christ Church (Front), St Aldates

| PLACE | MORSE | LEWIS | ENDEAVOUR |
|---|---|---|---|
| HIGH STREET | PLENTY | | |
| The Covered Market | Absolute Conviction<br>Greeks bearing Gifts<br>The Dead of Jericho<br>Last Bus to Woodstock | The Soul of Genius<br>Down Among the Fearful | Cartouche |
| Wheatsheaf Passage | The Dead of Jericho | The Gift of Promise | |
| Carfax | The Last Enemy<br>Greeks Bearing Gifts<br>Happy Families<br>Death is now my neighbour | | |
| Bear inn | Absolute Conviction | | |
| Town Hall ballroom | The Secret of Bay 5 b | | |
| Cornmarket | The Last Enemy | | |
| Old Court Room. Town Hall | Service of All the Dead | | |

| PLACE | MORSE | LEWIS | ENDEAVOUR |
|---|---|---|---|
| | The Wench is Dead<br>The Last Enemy | | |
| Oxford Union | The Infernal Serpent<br>Greeks Bearing Gifts | Old School Ties<br>Point of Vanishing<br>The Indelible Stain | Colours<br>Confection<br>Oracle |
| Modern Art | Who Killed Harry Field? | | |
| Pembroke College | Who Killed Harry Field? | Deceived by Flight<br>Counter Culture Blues | |
| Christ Church Tom Quad | Twilight of the Gods<br>The Daughters of Cain | Down Among the Fearful | |
| Queen's Lane | The Secret of Bay 5B<br>The Silent World of Nicholas Quinn | And the Moonbeams Kiss the Sea<br>Music To Die for,<br>The Point of Vanishing<br>Dark Matter<br>The Gift of Promise<br>The Lions of Nemea | Fugue<br>Trove,<br>Arcadia<br>Lazaretto<br>Deguello |
| 88 St Aldate's | Deadly slumber | | |
| The Police Station | Too many to list | | |
| Oriel College | | Old School Ties | |

## 4 – Sheldonian to Merton Street Area

| PLACE | MORSE | LEWIS | ENDEAVOUR |
|---|---|---|---|
| Sheldonian Quad | The Dead of Jericho<br>The Ghost in the Machine<br>The Last Enemy<br>Dead on Time<br>Twilight of the Gods | | Fugue,<br>Ride<br>Arcadia<br>Prey<br>Game<br>Cartouche<br>Harvest |
| Sheldonian Theatre | The Silent World of Nicholas Quinn | Life Born of Fire (outside),<br>Ramlin' Boy (outside) | Fugue,<br>Ride<br>Arcadia<br>Prey |

| PLACE | *MORSE* | *LEWIS* | *ENDEAVOUR* |
|---|---|---|---|
| | The Wolvercote Tongue Second Time Round Dead on Time Twilight of the Gods Last Seen Wearing The Last Enemy The Silent World of Nicholas Quinn | | Game |
| Hertford College | The Last Bus to Woodstock The Ghost in the Machine Dead on Time The Service of All the Dead | The Great and the Good Allegory of Love Wild Justice | First Bus to Woodstock, Girl Trove Arcadia Game Harvest |
| Old Schools Quadrangle | The Settling of the Sun Absolute Conviction Twilight of the Gods The Wench is Dead | | Fugue, Harvest, Deguello |
| Catte Street/Hertford College | | Reputation, And the Moonbeams Kiss the sea Life Born of Fire, Allegory of Love, The Dead of Winter The Gift of Promise, Generation of Vipers, The Indelible Stain, Ramblin Boy Entry Wounds The Lions of nemea Beyond Good and Evil One for Sorrow | First Bus to Woodstock Girl Trove Game Fugue Home Sway Harvest Arcadia Apollo Deguello Prey Harvest |

| PLACE | MORSE | LEWIS | ENDEAVOUR |
|---|---|---|---|
| | | And the Moonbeams Kiss the sea<br>Life Born of Fire, Allegory of Love, The Dead of Winter<br>The Gift of Promise, Generation of Vipers,<br>The Lions of nemea<br>Beyond Good and Evil<br>One for Sorrow | |
| New College | Fat Chance<br>The Wolvercote Tongue<br>Happy Families | Whom the Gods would destroy<br>Wild Justice<br>Beyond Good and Evil | Apollo<br>Sway<br>Canticle |
| Exeter College | The Way Through the Woods<br>The Remorseful Day<br>The Settling of the Sun<br>The Silent World of Nicholas Quinn | Expiation<br>Life Born of Fire<br>The Quality of Mercy, Soul of Genius | Fugue<br>Home<br>Nocturne<br>Ride<br>Arcadia<br>Coda<br>Harvest<br>Muse |
| Radcliffe Camera/Square | The Dead of Jericho<br>Last Bust to Woodstock<br>The Last Enemy<br>The Settling of the Sun<br>The Way through the Woods<br>Absolute Convictions<br>The Silent world of Nicholas Quinn<br>Twilight of the Gods<br>The Daughters of Cain | | Girl<br>Rocket<br>Home<br>Neverland<br>Ride,<br>Arcadia<br>Coda<br>Game<br>Canticle<br>Cartouche<br>Lazaretto<br>Harvest<br>Zenana Girl<br>Neverland<br>Arcadia |
| Brasenose College | Settling of the sun | Life Born of Fire, | Neverland, |

| PLACE | *MORSE* | *LEWIS* | *ENDEAVOUR* |
|---|---|---|---|
| | The Silent World of Nicholas Quinn<br>Death is Now My Neighbour<br>Twilight of the gods<br>The Last Enemy | The Dead of Winter,<br>Intelligent Design<br>One for Sorrow<br>The Dead of Winter | Arcadia<br>Harvest<br>Quartet |
| Brasenose Lane/Wall of Exeter College | The Silent World of Nicholas Quinn | Whom The Gods Would Destroy<br>Expiation<br>The Great and the Good,<br>Allegory of Love<br>The Quality of Mercy<br>Counter Culture Blues<br>Falling Darkness<br>The Mind has Mountains<br>The Soul of Genius<br>Down Among the Fearful<br>Beyond Good & Evil | Girl.<br>Home<br>Trove.<br>Nocturne<br>Sway<br>Neverland<br>Arcadia<br>Muse<br>Game<br>Apollo |
| St Mary the Virgin + Vaults | The Settling of the Sun<br>The Silent World of Nicholas Quinn | Old School Ties<br>And The Moonbeams Kiss the Sea<br>Generation of Vipers What Lies Tangled<br>The Gift of Promise | Game<br>Lazaretto |
| Market Street | | Whom the Gods would destroy<br>The Point of Vanishing<br>Falling Darkness<br>Generation of Vipers<br>Fearful Symmetry<br>Down Among the Fearful<br>Magnum Opus | Girl.<br>Ride<br>Coda |
| King Edward Street | | Life Born of Fire | Sway |

| PLACE | *MORSE* | *LEWIS* | *ENDEAVOUR* |
|---|---|---|---|
| | | The Great and The Good Wild Justice Generation of Vipers | First Bus to Woodstock |
| The Bear | Absolute Conviction | | Cartouche |
| Oriel College | The Silent World of Nicholas Quinn The Infernal Serpent The Settling of the Sun Ghost in the Machine Deadly Slumber Death is Now My Neighbour | Whom the Gods would destroy The Quality of Mercy The point of Vanishing Dark Matters Dark Matters Old School Ties Magnum Opus | Confection |
| Oriel Square | Last Seen Wearing Second Time Round The Infernal Serpent | Reputation Counter Culture Blues Wild Justice Entry Wounds | First Bus to Woodstock Trove |
| University College | The Infernal Serpent | And the Moon-beams Kissed the sea Allegory of Love The Mind has Mountains | |
| Christ Church College plus Gate and Library | The Wolvercote Tongue Last Seen Wearing The Daughters of Cain Deadly Slumber Who Killed Harry Field? Twilight of the Gods | Down Among The Fearful | Trove |
| Logic Lane | | The Mind has Mountains Down Among The Fearful | Game |
| Grove Walk | | Old School Ties Life Born of Fire | Arcadia |
| Corpus Christi College | The Last Enemy | And the Moon-beams Kissed the Sea | |

| PLACE | *MORSE* | *LEWIS* | *ENDEAVOUR* |
|---|---|---|---|
| | | Wild Justice Intelligent Design Entry Wounds | |
| Magpie Lane | Deadly Slumber | Old School Ties Wild Justice, What Lies Tangled | Zenana |
| Merton Street | The Silent World of Nicholas Quinn | Old School Ties And the Moonbeams Kiss the Sea Music to Die For Life Born of Fire The Great and the good Counter Culture Blues Dark Matter, Your Sudden Death Question Wild Justice Down Among the Fearful Entry Wounds What Lies Tangled | Fugue Trove Nocturne Arcadia Coda Game Muse Confection Oracle Raga |
| Merton College | The Service of All the Dead The Infernal Serpent | Old School Ties Your Sudden Death Question | Zenana Trove Sway Lazaretto |
| Christ Church Meadow | | The Gift of Promise, Entry Wounds, | First Bus to Woodstock Trove Arcadia Game Icarus |

## 5 – Magdalen Bridge Area

| PLACE | *MORSE* | *LEWIS* | *ENDEAVOUR* |
|---|---|---|---|
| Magdalen College | Dead on Time Death is now thy neighbour The Dead of Jericho Twilight of the Gods Greeks Bearing Gifts | Whom the Gods Would Destroy Allegory of Love The Point of Vanishing Dark Matter Magnum Opus | Trove, Game Harvest Pylon |

| PLACE | | | |
|---|---|---|---|
| | The Remorseful Day | | |
| Botanic Gardens | The Silent World of Nicholas Quinn<br>The Settling of the Sun<br>Death is Now My Neighbour | Reputation<br>Old School Ties<br>And the Moonbeams Kiss the Sea<br>Music to Die for<br>Life Born of Fire<br>The Soul of Genius<br>Generation of Vipers | Harvest |
| Magdalen Bridge | Too many to list | Reputation<br>Expiation<br>Fearful Symmetry<br>Down Among the Fearful,<br>Ramblin' Boy<br>One for Sorrow | |
| Magdalen College School | Death is Now my Neighbour | | |
| St Catherine's College | | | Game |
| Mansfield College | | Life Born of Fire | |
| St Edmund Hall | | | Duguello |

## 6 – Around the Castle

| PLACE | *MORSE* (All) | *LEWIS* | *ENDEAVOUR* |
|---|---|---|---|
| Nuffield College | Fat Chance | | |
| Malmaison/Oxford Prison | The Way Through the Woods<br>The Wench is dead | Old School Ties | |
| Upper Fisher Row | | | Arcadia |

## 7 – Jericho Area

| PLACE | *MORSE* (All) | *LEWIS* | *ENDEAVOUR* |
|---|---|---|---|
| Combe Road | The Dead of Jericho | | |
| The Bookbinders Arms & Canal Street | The Dead of Jericho | | |

| 41 Nelson Street | | A life Born of Fire | |
|---|---|---|---|
| The Jericho Tavern | The Silent World of Nicholas Quinn | | |
| Phoenix Cinema | The Silent World of Nicholas Quinn | | |
| Le Petit Blanc | Death is Now My Neighbour | | |
| St Sepulchre's | The Wench is Dead | | |
| Green College The Observatory | The Dead of Jericho The Silent World of Nicholas Quinn | | |
| Old Radcliffe Infirmary | Too many to list | | |
| Walton Well Road | | | Coda |
| Port Meadow | | | Harvest |

## References

- *Discover Four Filming Locations of* Inspector Morse *and* Lewis! *Oxford Guides*: http://www.oxfordguides.co.uk/
- *Endeavour on Location*, by J. P. Sperati and Anthony J. Richards, Irregular Special Press, 2020
- *Morse in Oxford*, by Annie Bullen, Pitkin Publishing, 2018
- *The Oxford of* Inspector Morse *and* Lewis, by Bill Leonard, The History Press, 2008
- *Inspector Morse Country*, by Cliff Goodwin, Headline Publishing, 2002
- Best website: morseandlewisandendeavour.com

# Appendix 2

## Filmography

### *Morse*

#### Series 1

|  | Episode | Air Date | Directed by |
|---|---|---|---|
| Dead of Jericho | 1 | 6 Jan 1987 | Alastair Reid |
| The Silent World of Nicholas Quinn | 2 | 13 Jan 1987 | Brian Parker |
| Service of All the Dead | 3 | 20 Jan 1987 | Peter Hammond |

#### Series 2

|  | Episode | Air Date | Directed by |
|---|---|---|---|
| The Wolvercote Tongue | 4 | 25 Dec 1987 | Alastair Reid |
| Last Seen Wearing | 5 | 8 March 1988 | Edward Bennett |
| The Settling of The Sun | 6 | 15 March 1988 | Peter Hammond |
| Last Bus to Woodstock | 7 | 22 March 1988 | Peter Duffell |

#### Series 3

|  | Episode | Air Date | Directed by |
|---|---|---|---|
| Ghost in The Machine | 8 | 4 Jan 1989 | Herbert Wise |
| The Last Enemy | 9 | 11 Jan 1989 | James Scott |
| Deceived by Flight | 10 | 18 Jan 1989 | Anthony Simmons |
| The Secret of 5B | 11 | 25 Jan 1989 | Jim Goddard |

#### Series 4

|  | Episode | Air Date | Directed by |
|---|---|---|---|
| The Infernal Serpent | 12 | 3 Jan 1990 | John Madden |
| The Sins of The Fathers | 13 | 10 Jan 1990 | Peter Hammond |
| Driven to Distraction | 14 | 17 Jan 1990 | Sandy Johnson |
| Masonic Mysteries | 15 | 24 Jan 1990 | Danny Boyle |

## Series 5

|  | Episode | Air Date | Directed by |
|---|---|---|---|
| Second Time Around | 16 | 20 Feb 1991 | Adrian Shergold |
| Fat Chance | 17 | 27 Feb 1991 | Roy Battersby |
| Who Killed Harry Field? | 18 | 13 Mar 1991 | Colin Gregg |
| Greeks Bearing Gifts | 19 | 20 Mar 1991 | Adrian Shergold |
| Promised Land | 20 | 27 Mar 1991 | John Madden |

## Series 6

|  | Episode | Air Date | Directed by |
|---|---|---|---|
| Dead on Time | 21 | 26 Feb 1992 | John Madden |
| Happy Families | 22 | 11 Mar 1992 | Adrian Shergold |
| The Death of the self | 23 | 25 Mar 1992 | Colin Gregg |
| Absolute Conviction | 24 | 8 Apr 1992 | Antonia Bird |
| Cherubim and Seraphim | 25 | 15 Apr 1992 | Danny Boyle |

## Series 7

|  | Episode | Air Date | Directed by |
|---|---|---|---|
| Deadly Slumber | 26 | 6 Jan 1993 | Stuart Orme |
| Day of The Devil | 27 | 13 Jan 1993 |  |
| Twilight of The Gods | 28 | 20 Jan 1993 | Herbert Wise |

## Series 8 / specials

|  | Episode | Air Date | Directed by |
|---|---|---|---|
| The Way Through the Woods | 29 | 29 Nov 1995 | John Madden |
| The Daughters of Cain | 30 | 27 Nov 1996 | Herbert Wise |
| Death is now my Neighbour | 31 | 19 Nov 1997 | Charles Beeson |
| The Wench is Dead | 32 | 11 Nov 1998 | Robert Knights |
| The Remorseful Day | 33 | 15 Nov 2000 | Jack Gold |

# Lewis

## Series 1

|  | Episode | Air Date | Directed by |
|---|---|---|---|
| Reputation | 1 | 29 Jan 2006 | Bill Anderson |
| Whom the Gods would Destroy | 2 | 18 Feb 2007 | Marc Jobst |
| Old School Ties | 3 | 25 Feb 2007 | Sarah Harding |
| Expiation | 4 | 4 Mar 2007 | Dan Reed |

## Series 2

|  | Episode | Air Date | Directed by |
|---|---|---|---|
| And The Moonbeams Kiss the Sea | 5 | 24 Feb 2008 | Dan Reed |
| Music to Die For | 6 | 2 Mar 2008 | Bill Anderson |
| Life Born of Fire | 7 | 9 Mar 2008 | Richard Spence |
| The Great and The Good | 8 | 16 Mar 2008 | Stuart Orme |

## Series 3

|  | Episode | Air Date | Directed by |
|---|---|---|---|
| Allegory of Love | 9 | 22 Mar 2009 | Bill Anderson |
| The Point of Vanishing | 11 | 5 Apr 2009 | Maurice Phillips |
| Counter Culture Blues | 12 | 12 Apr 2009 | Bill Anderson |

## Series 4

|  | Episode | Air Date | Directed by |
|---|---|---|---|
| The Dead of Winter | 13 | 2 May 2010 | Bill Anderson |
| Dark Matter | 14 | 9 May 2010 | Billie Eltringham |
| Your sudden death question | 15 | 16 May 2010 | Dan Reed |
| Falling Darkness | 16 | 30 May 2010 | Nicholas Renton |

## Series 5

|  | Episode | Air Date | Directed by |
|---|---|---|---|
| Old, unhappy, Far Off Things | 17 | 3 Apr 2011 | Nicholas Renton |
| Wild Justice | 18 | 10 Apr 2011 | Hettie Macdonald |
| The Mind has Mountains | 19 | 17 Apr 2011 | Charles Palmer |
| The Gift of Promise | 20 | 24 Apr 2011 | Metin Hüseyin |

## Series 6

|  | Episode | Air Date | Directed by |
|---|---|---|---|
| The Soul of Genius | 21 | 16 May 2012 | Brian Kelly |
| Generation of Vipers | 22 | 23 May 2012 | David O.Neill |
| Fearful Symmetry | 23 | 30 May 2012 | Nicholas Renton |
| The Indelible Stain | 24 | 6 June 2012 | Tim Fywell |

## Series 7

|  | Episode | Air Date | Directed by |
|---|---|---|---|
| Down Among the Fearful | 25 | 7 Jan & 14 Jan 2013 | Brian Kelly |
| The Ramblin' Boy | 26 | 21 & 28 Jan 2013 | Dan Reed |
| Intelligent Design | 27 | 4 Feb & 11 Feb 2013 | Tim Flywell |

## Series 8

|  | Episode | Air Date | Directed by |
|---|---|---|---|
| Entry Wounds | 28 | 10 Oct & 17 Oct 2014 | Nicholas Renton |
| The Lions of Nemea | 29 | 24 Oct & 31 Oct 2014 | Nick Laughland |
| Beyond Good and Evil | 30 | 7 Nov & 14 Nov 2014 | David Drury |

## Series 9

|  | Episode | Air Date | Directed by |
|---|---|---|---|
| One for Sorrow | 31 | 6 Oct & 13 Oct 2015 | Nick Laughland |
| Magnum Opus | 32 | 20 Oct & 27 Oct 2015 | Matthew Evans |
| What Lies Tangled | 33 | 3 Nov & 10 Nov 2015 | David Drury |

# Endeavour

## Pilot

|  | Episode | Air Date | Directed by |
|---|---|---|---|
| Pilot | 1 | 2 Jan 2012 | Colm McCarthy |

## Series 1

|  | Episode | Air Date | Directed by |
|---|---|---|---|
| Girl | 2 | 14 April 2013 | Edward Bazalgette |
| Fugue | 3 | 21 April 2013 | Tom Vaughan |
| Rocket | 4 | 28 April 2013 | Craig Viveiros |
| Home | 5 | 5 May 2013 | Colm McCarthy |

## Series 2

|  | Episode | Air Date | Directed by |
|---|---|---|---|
| Trove | 6 | 30 March 2014 | Kristoffer Nyholm |
| Nocturne | 7 | 6 Apr 2014 | Giuseppe Capotondi |
| Sway | 8 | 13 Apr 2014 | Andy Wilson |
| Neverland | 9 | 20 Apr 2014 | Geoffrey Sax |

## Series 3

|  | Episode | Air Date | Directed by |
|---|---|---|---|
| Ride | 10 | 3 Jan 2016 | Sandra Goldbacher |
| Arcadia | 11 | 10 Jan 2016 | Bryn Higgins |
| Prey | 12 | 17 Jan 2016 | Lawrence Gough |
| Coda | 13 | 24 Jan 2016 | Oliver Blackburn |

## Series 4

|  | Episode | Air Date | Directed by |
|---|---|---|---|
| Game | 14 | 8 Jan 2017 | Ashley Pearce |
| Canticle | 15 | 15 Jan 2017 | Michael Lennox |
| Lazaretto | 16 | 22 Jan 2017 | Börkur Sigþórsson |
| Harvest | 17 | 29 Jan 2017 | Jim Loach |

## Series 5

|  | Episode | Air Date | Directed by |
|---|---|---|---|
| Muse | 18 | 4 Feb 2018 | Brady Hood |
| Cartouche | 19 | 11 Feb 2018 | Andy Wilson |
| Passenger | 20 | 18 Feb 2018 | Jim Field Smith |
| Colours | 21 | 25 Feb 2018 | Robert Quinn |
| Quartet | 22 | 4 Mar 2018 | Geoffrey Sax |
| Icarus | 23 | 11 Mar 2018 | Gordon Anderson |

## Series 6

|            | Episode | Air Date    | Directed by     |
|------------|---------|-------------|-----------------|
| Pylon      | 24      | 10 Feb 2019 | Johnny Kenton   |
| Apollo     | 25      | 17 Feb 2019 | Shaun Evans     |
| Confection | 26      | 24 Feb 2019 | Leanne Welham   |
| Deguello   | 27      | 3 Mar 2019  | Jamie Donoughue |

## Series 7

|        | Episode | Air Date    | Directed by |
|--------|---------|-------------|-------------|
| Oracle | 28      | 9 Feb 2020  | Shaun Evans |
| Raga   | 29      | 16 Feb 2020 | Zam Salim   |
| Zenana | 30      | 23 Feb 2020 | Kate Saxon  |

## Series 8

|          | Episode | Air Date      | Directed by |
|----------|---------|---------------|-------------|
| Striker  | 31      | 12 Sept. 2021 | Shaun Evans |
| Terminus | 32      | 9 Sept. 2021  | Ian Aryeh   |
| Saxon    | 33      | 26 Sept. 2021 | Kate Saxon  |

# Appendix 3

# Illustrations

| Page no | Picture/illustration |
|---|---|
| Page 9 | Big Morseland Map |
| | 8 Mini maps + Jericho |
| | By Sebastian Ballard |
| Page 13 | Heidi Boon pictures in this section |
| | By Phil Knight and Heidi Boon |
| Page 56 | Colin Dexter |
| Page 64 | Drinking with Dexter |
| Page 68 | Book Cover Silent world of Nicholas Quinn |
| Page 74 | Book Cover Last Bus to Woodstock |
| Page 80 | Fawley's Oxford Courtesy Cara Hunter |
| Page 86 | Morse and Jaguar |
| Page 96 | Early and Late *Morse* Express/Star |
| | By Jonathan Ford/ITV |
| Page 114 | Oxford Map |
| Page 117 | Map detail |
| Page 118 | Map |
| Page 118 | Map Detail |
| Page 124 | Morseland |
| | By Sebastian Ballard |

Find out more about Bite-Sized Books here:

More books by John Mair here:

Find out more about Heidi Rickard's Walking Tours of Oxford:

Have a book you'll like us to publish? – look at our helpful guide for authors:

Printed in Great Britain
by Amazon